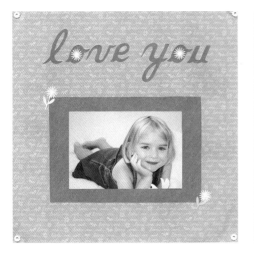

meet the best of the best

Drawing on a rich tradition in the decorative arts, UK scrapbookers have a style all their own. It's fresh, it's elegant, and it's sophisticated but never stodgy. Our Best of the Best designers have created layouts that are bound to inspire you to have a go. Plus, they've shared their personal philosophies about scrapbooking as well as lots of helpful tips and techniques. One look at their pages and you're sure to agree: They're simply The Best!

OUR DESIGNERS

top row, from left to right

MANDY ANDERSON
Selsey, West Sussex

ALISON DOCHERTY
Pentwyn, Cardiff

SAM EVERETT
Ickenham, Middlesex

GISELLE HOMER
Portishead, Bristol

centre row, from left to right

CARRIE HOWARD
Camberley, Surrey

VENESSA MATTHEWS
Ruislip, Middlesex

ANNE PARRY
Bushey, Hertfordshire

ALISON PENSTONE
Bracknell, Berkshire

bottom row, from left to right

ALISON ROWE
Ascot, Berkshire

MICHELLE THOMPSON
Somersham, Cambridgeshire

SARAH WHEATLEY
Hurstpierpoint, West Sussex

DEBBIE WOOD
Surbiton, Surrey

A NOTE ABOUT OUR MATERIALS AND FONT LISTINGS
We chose to list materials primarily by manufacturer since that is how stockists buy them. If a stockist is carrying any products by that manufacturer, odds are they can order whatever you want in that manufacturer's range. We decided to list font names inside parentheses. Unless specified otherwise, the fonts on the layouts were downloaded from the Internet.

VISIT OUR WEBSITE
The W icon ⓦ directs you to our website www.britishscrapbooking.com for more information and ideas. Our website features an index of designer names and projects, plus an interview with each of our Best of the Best designers.

The judges tackled mounds of entries. Starting upper left, clockwise: Beverley Stephenson, Shimelle Laine, Joanna Campbell Slan, and Mary Anne Walters.

A Note from Joanna:

On a quiet morning in June, four of us—Shimelle Laine, Beverley Stephenson, Mary Anne Walters, and I—gathered in Sunningdale, Berkshire, at the house of Peter and Lesley Hindmarsh. We had an awesome task before us. From a huge group of entries, we were charged with selecting the layouts to be honoured as **The Best of British Scrapbooking.**

My fellow judges and I had only met online. Like so many scrapbookers, we knew each other through emails and posts, but not in person. A nurse was scheduled to visit Lesley that morning, so I kept opening the front door and asking, 'Are you a health care provider or a scrapbooker?' As a conversation starter, it worked brilliantly. Pretty soon we were all laughing and chatting like old friends. Then we sat down to serious work.

The layouts. Oh, the layouts. We were knocked out. Gobsmacked. The quality of work was amazing, absolutely fabulous. In the end, we expanded the number of honourable mentions because we wanted to showcase as much talent as possible.

By the evening, we were ready to call our winners with our congratulations. We took turns making the calls, and our hands were shaking so badly that we probably misdialed each number at least once. We were as thrilled as our winners.

That's the story of how this little book came into the world. I've been in scrapbooking almost since its inception. I've seen a lot of pages, worked for all three major scrapbook magazines, and taught classes around the world. But I've never seen work as dynamic and polished as this.

When our work was finished and we looked it over, one thing was missing. The United Kingdom has a rich history of paper crafts. Many crafters move back and forth between scrapbooking and cardmaking. So we asked papercrafters from around the UK to share their best cards with us. Those images, we felt, rounded out our book.

Now turn off the telly, switch on your answer phone, grab a packet of McVities, and pour yourself a proper cuppa. You are in for a real treat.

Cheers—

Joanna

contents

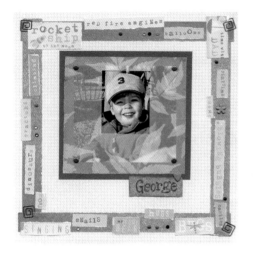

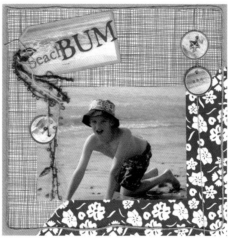

This book is dedicated to scrapbookers and cardmakers all over the world. Our goal is to inspire, share, and encourage. The featured designers you'll meet inside are just a few of the wonderful people involved in papercrafting. Their generosity of spirit and their willingness to share their ideas and their work made this book possible. More specifically, we dedicate this book to Sarah Wheatley, who will always have a special place in our hearts.

Joanna Campbell Slan

mandy anderson

SELSEY, WEST SUSSEX

I enjoy the creative process as a layout evolves before my eyes, building, layering and putting in the finishing touches with little bits and pieces. Giving the layout that little extra panache is my passion MA

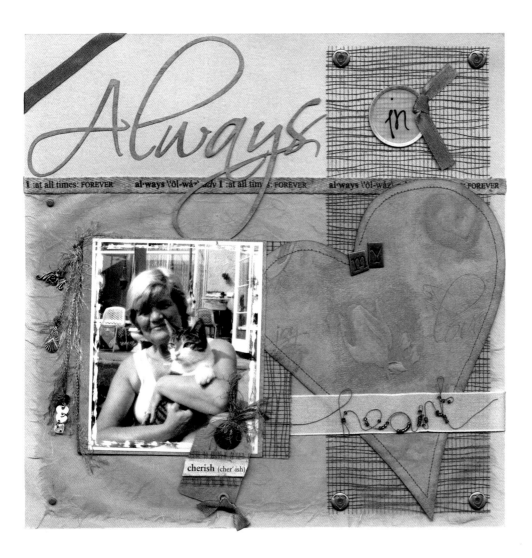

always in my heart
cardstock: Bazzill Basics
cardstock: Club Scrap
mulberry paper
Maruyama paper: Magenta
twill tape: 7gypsies
rub-on words: Making Memories
wire, random letters and heart
eyelets: Making Memories
metal rim tag and definition
sticker: Washer Word
charms
beads
ribbon
fibres
mini-brads
font (Scriptina)

The mounted black and white photo opens to reveal a letter printed on mulberry paper. Although Mandy's mother is deceased, Mandy wrote directly to her as though she were still alive. Mandy used the first person, saying, 'I can almost feel your touch as I remember the happy times.' For a unique journaling experience, write a letter to someone you love. Letters often help us to put our most intimate thoughts on paper.

The tag above right is an example of Mandy's passion for details.

tip Add interest with Maruyama. It's a Japanese paper that comes in a variety of weaves and colours. Here an open weave, a mesh, has been used under the heart and the photo. Maruyama is not self-adhesive. Mandy shows us two options for attaching it, either with brads or with adhesive hidden under an element (like under the word 'cherish' on the tag).

tip Warm your wire by running it through a clenched fist before you manipulate it. Warming makes the wire more malleable. Mandy mounted beads on wire and then created the word 'heart'. The wire word is backed with a light-coloured ribbon so it doesn't get lost on the page.

tip Scuff the edges of your photos with sandpaper. Here the scuffing makes an irregular white border that adds emphasis to the subject.

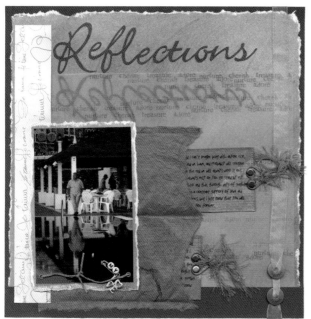

reflections of my love
paper: Terri Martin
cardstock: Bazzill Basics
mulberry paper
vellum
script paper: Sonnets
ribbon
fibres
washer words, circle letters,
snaps, heart clips, eyelets:
Making Memories
earring
alphabet beads
raffia
font (Bickley)

Taking her cue from her husband's reflection in the photo, Mandy created her page title and a mirror image of that page title which she then secured under printed vellum for a soft effect. Machine stitched pockets of mulberry paper hold her journaling tags. Mandy printed her journaling on transparencies, cut the transparencies to the size of her tags, and stitched them onto a background of card and printed paper.

There are many different ways to create mirror images of your words. Here's one: Handcut the words the 'right way,' flip the words onto their 'wrong side,' trace them on your paper, and handcut the words again as mirror images. ☺

tip Dangle charms from your photo. Thread raffia through two eyelets in the bottom of your photo, string charms on your raffia, and tie the two loose ends together.

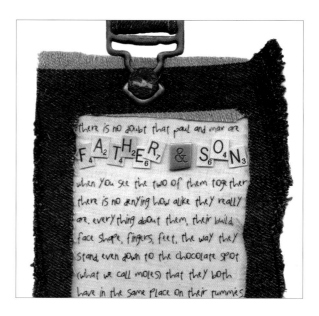

it's all in the genes
cardstock: Bazzill Basics
denim
Hessian fabric
cotton
dungaree clips
brads
letters (Scrabble), stamp alphabet (Rummage): Making Memories
twill tape
metal letters: 7gypsies
stamps: Wordsworth
transparency
font (StringBean)

First, Mandy stamped words around the outside edge of her mat. Then she attached Hessian cloth (burlap) to the blue cardstock, hiding the adhesive under various page elements. The denim jeans she used were destined for the bin before she chopped them up. Mandy printed her journaling on a transparency which she layered over the cotton fabric.

The letters 'g', 'n', and 's' are stitched in a tight zigzag design, then they were cut from the denim fabric for use on the page.

A tight zigzag will give you a solid line of thread that won't unravel.

tip Mount fabric on cardstock for a unique page background. The looser the weave, the more of your cardstock will show. You can fray the fabric edges for a softer look.

tip Overlap your letter tiles when you run out of room. Mandy did this with 'father and son' to fit more letters in the tight space.

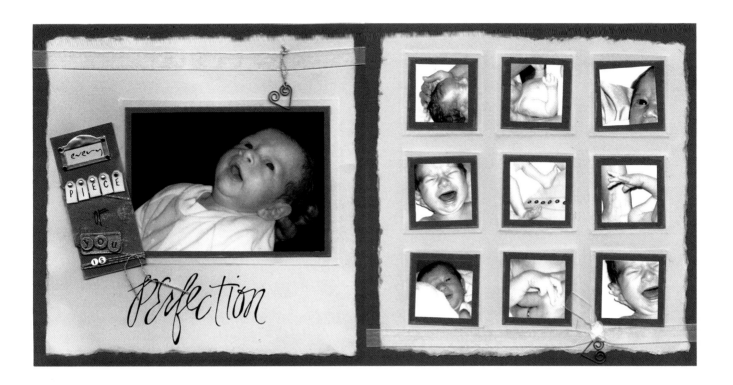

perfection

cardstock: Bazzill Basics
ribbon
gold rub-on: Craf-T Products
fibres
heart clip, brads, label holder,
metal eyelet letters, vellum tag:
Making Memories
rub-on words: Making Memories
alphabet beads
font (Inkburrow)

Mandy matted each of her photos
and then dry embossed a frame
around them. The embossed
frame adds subtle emphasis. ⓦ

tip Accent your embellishments
and paper with Metallic Rub-Ons
by Craf-T Products. Mandy
applied the rub-on to her ribbon
before she added the word 'of.'
She also used gold rub-on to
edge the mats and the tiny tags
that spell 'piece.' Apply the
product with a finger, a sponge
applicator, or a cotton tip swab.
The rub-on can be buffed for a
higher shine. Spray your finished
item with a fixative to seal it,
if necessary.

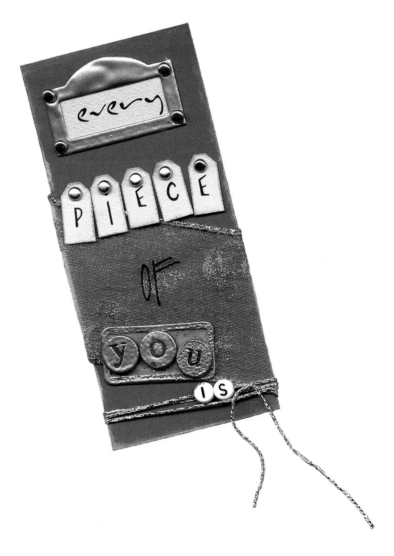

alison docherty

PENTWYN, CARDIFF

I love mixing patterned papers, layering them and combining ones that you would never think would go together. I also love fibres—the texture and richness of them AD

abundance *this page, right*
cardstock: Bazzill Basics
cork paper, transparencies:
Magic Scraps
word stickers: K&Company
paint samples
rub-on words, page pebbles:
Making Memories
spiral clips

Alison lets her embellishments do her journaling by using word stickers under page pebbles. You can fake the look of page pebbles by pouring a puddle of Diamond Glaze on your word stickers. Let the Diamond Glaze dry before putting the stickers on your page.

tip No need to pinch paint samples from your local DIY store. Instead, look for similar products in scrapbook stores. One such product is Paint Stripz by PM designs. They are 5 cm by 30.5 cm (2" x 12"), acid-free, and available in a variety of colours.

bliss *opposite page, top*
cardstock: Bazzill Basics
patterned paper:
Paper Adventures, 7gypsies,
Pebbles Inc.
stamp: Hero Arts
page title: Hot Off the Press
eyelets and date stamp:
Making Memories
beads
button: Scrapworld
wire

Alison combined five different patterned papers in this layout, but they all work together.

If you are unsure about mixing and matching papers, start by working with a range that offers coordinated products. This trains your eye to be more comfortable with the possibilities. You might also want to have a go at mixing monochromatic patterned papers. Interior designers are experts at mixing different patterns. Studying home décor magazines is a good way to build your confidence. ⓦ

tip Thread wire through eyelets, then string beads on the wire to create a border like Alison did. Remember, with an even number of holes, the end of your wire (or fibre) will come out on the same side as you started. With an odd number of holes, your wire will come out on the opposite side. It's a good idea to use a pencil to mark your paper for the eyelets before you begin.

tip Create a patterned background by stamping solid cardstock with an image. The stamp Alison used combines a phrase and a postal mark.

my boy *opposite page, bottom*
cardstock: Bazzill Basics
patterned papers: 7gypsies,
Pebbles Inc.
transparency and photo holder:
7gypsies
charms: Weenie Bits,
Making Memories, Magic Scraps
material
fibres

Alison layered transparency film printed with handwritten script on top of her background paper and over her fabric tag. Transparency film is versatile: you can run it through your printer, paint on it, and stamp on it. The single gold filigree photo corner—positioned diagonally to the two gold charms on the tag—attracts attention. Another interesting idea is to use just two photo corners and position them diagonally from each other.

tip Save bits of interesting fabric to use as photo mats. Upholstery fabric works particularly well. You can even unravel the fabric and use the threads as fibre. Turn fabric over and consider using the 'wrong' side for its muted image. For an inexpensive source of fabric, ask your local fabric stockist or tailor if you can have her discards.

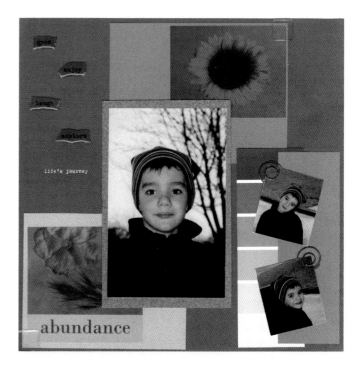

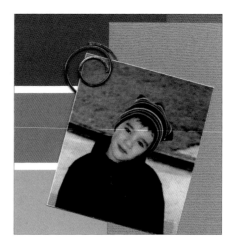

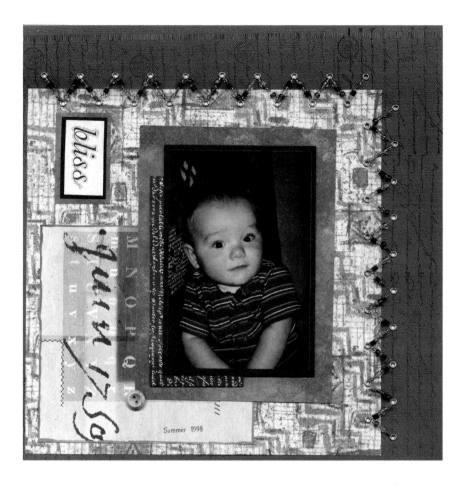

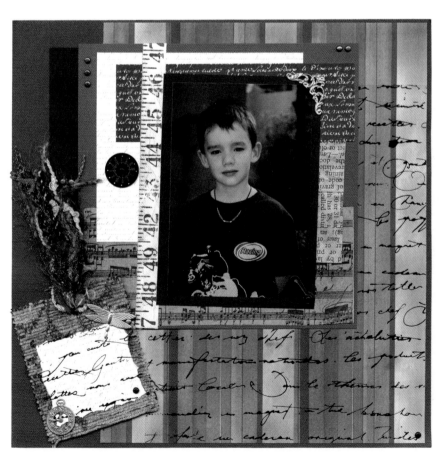

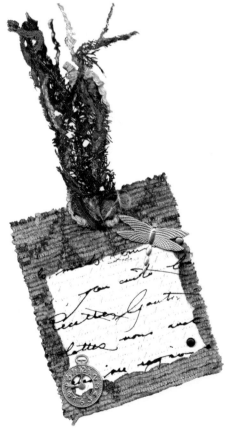

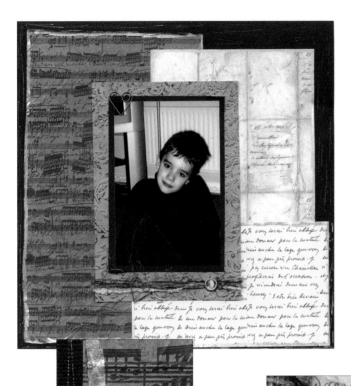

lewis *top*
cardstock: Bazzill Basics
tissue paper, patterned paper,
photo corners: 7gypsies
fibres
charms: Making Memories
gold ring: Scrapworks
gold leafing pen: Krylon

Alison added streaks to the solid
black background with her gold
pen. Adding streaks of contrasting
or neutral ink is a great way to
soften any solid colour.

tip Extend your mat below your
photo and wrap fibres around the
extra paper. The fibres add texture
to your layout and give you a
great place to attach charms.

sweetheart *bottom*
cardstock: Bazzill Basics
patterned papers: 7gypsies,
Pebbles Inc.
tissue paper: 7gypsies
beads and mesh: Magic Scraps
buttons, Hessian material:
Scrapworld
fibres: Weenie Bits
rickrack fibre
metal button
gold leafing pen: Krylon

A piece of Hessian material is
folded over Alison's photo to
'crop' it and to provide a
background for fibres and beads.
Several papers were crumpled
and flattened before being
attached to the page. If you are
going to crumple your paper
before using it, cut the paper
slightly larger than you require
because crumpling leaves paper
smaller than its original size.

tip Use fine wire as thread for
attaching beads to your pages.
See your bead stockist for a
suitable needle.

The undulating shape of the black
mesh makes it all the more
attractive. Alison brushed the
mesh with gold to give it
highlights and make it blend
with the rest of her page. To
shape mesh like this you need a
strong and flexible adhesive like
Glue Dots.

tip Scout out scrapbook
supplies in your local fabric and
needlework store. That's where
Alison found the buttons and the
rickrack ribbon. You can also look
in charity shops like Oxfam or
Cancer Research for old clothes
with trim you could use on your
pages. You'll be recycling, doing a
good deed, and scrapping all at
the same time.

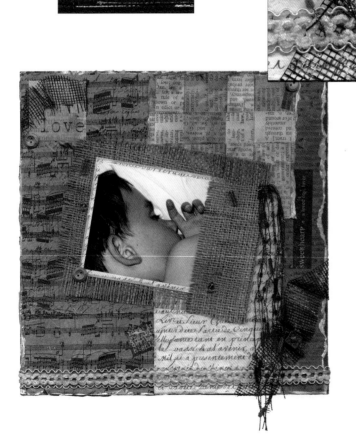

Scrapbooking became therapy for Sam when she suffered from Postnatal Depression.
Now when she's feeling blue, she knows that working on a page will lift her spirits.

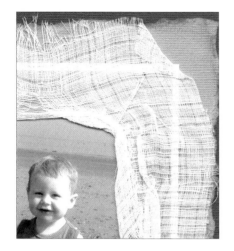

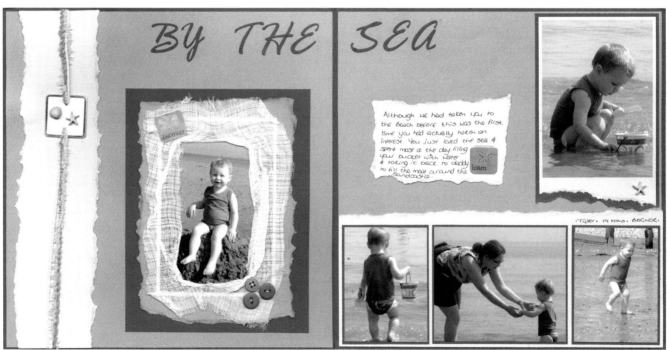

by the sea
cardstock: Bazzill Basics
poemstones: Creative
Imaginations
fibres
buttons
chalk
tag: Making Memories
muslin
title font (Sonja)

Sam created a soft, breezy frame by tacking the muslin back with stitches around her dominant photo. To loosen the weave, she pulled a few threads from the muslin before attaching it to her page. You can dye muslin. Mix a dab of acrylic paint with some white glue thinned with water. Dip your fabric into the mixture and let it dry. Obviously, the mix will run if exposed to water.

tip Handcut your titles on a glass mat instead of a self-healing mat. Sam says, 'I used to find handcutting titles such hard work until a friend recommended cutting on glass. Glass is so much easier.' You can use a piece of glass from a picture frame as your mat, but you'll want to tape the edges so you don't get cut.

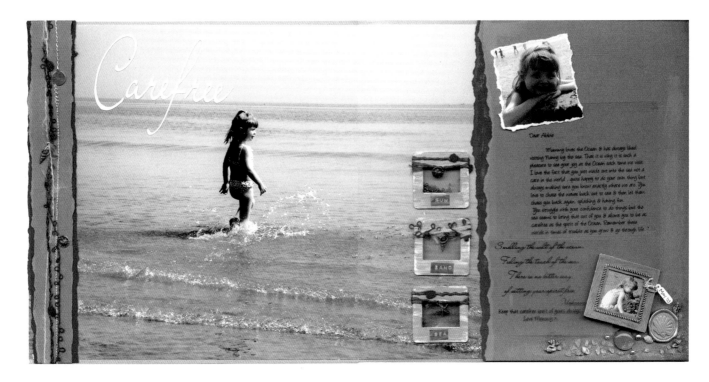

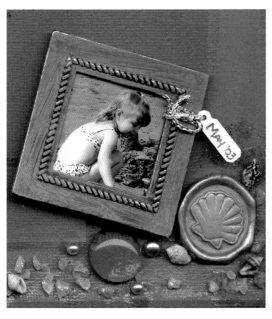

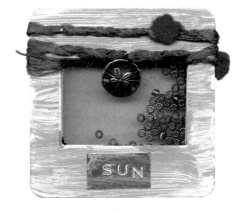

carefree
cardstock: Bazzill Basics
fibres, charms, seashells, slide
mounts: Wiggly Woods
beads
labeling tape: Dymo
acrylic paint: Anita's Craft
faux wax seal:
Creative Imaginations
charmed frame: Making Memories
small tag
glass rubble: Scrapbook Bits
page pebble
transparency: 3M
title font (Lainie Days Script)

Sam enlarged a gorgeous photo to nearly fill her page. The slide mounts are used as frames for the shaker boxes filled with blue and green beads. Sam added acrylic paint to her background cardstock to match it to the colours of her large photo.

The mini-collage in the lower right corner of the right hand scrapbook page includes real sand and shells. A collage of three-dimensional items is called an assemblage.

Sam wiped acrylic paint over both the slide mount and the Dymo label for a soft look that blends with her page.

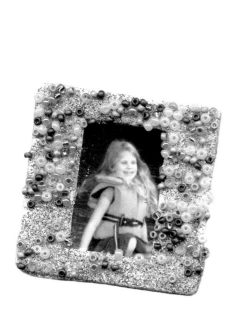

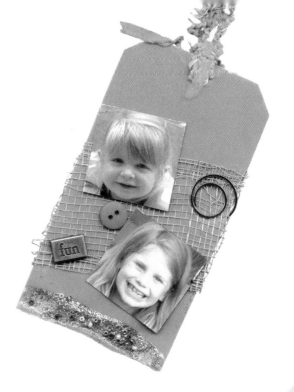

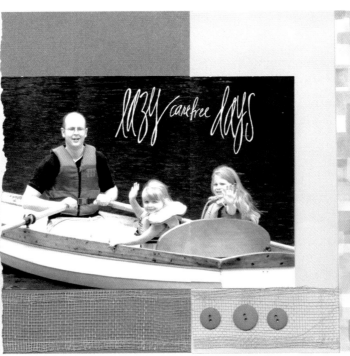

lazy carefree days
cardstock: Bazzill Basics
patterned paper: Magenta
coastal netting: Magic Scraps
buttons, photo flips, rub-on
words, circular clip, metal word:
Making Memories
fibres: Fibres by the Yard
slide mounts: Scraptastic
beads

Under the hinged photo is Sam's
journaling about a special outing
her daughters enjoy regularly with
their father. Sam notes that the
girls 'love to race down to the
boathouse to pick out their life
jackets and find the number of the
boat they need to use.' Details
which might seem small today will
bring a memory vividly to mind
tomorrow.

tip Describe specifics when you
write. Sam could have omitted
how the girls pick out their life
jackets and find the number of the
boat, but these additions make
her journaling more compelling
and more real.

tip Make your slide mounts
coordinate with your patterned or
solid paper by adding paint, glitter
or beads. Sam repeated the same
glitter and bead combination on
the tag on the right hand page of
her layout.

giselle homer

PORTISHEAD, BRISTOL

Scrapbooking encompasses many other crafts that I enjoy. I like the idea of doing a craft that I can keep for my family. With most other crafts you tend to give them away. GH

george's favourite things
paper: Daisy D's,
Hot Off The Press
word and phrase paper:
K&Company
vellum: Hobbycraft
eyelets, brads, heart clips:
Making Memories
title: hand-lettered

Giselle catalogued George's favourite things as a frame around his portrait. An overlay of vellum diffuses the background of the photo. A mat of solid green paper 2 cm wide peeps out from under the leaf-printed vellum, picking up and repeating the colour of George's jumper.

tip Make a list of a loved one's favourite things. They may change over time so don't forget to date the list. Looking back on your list should be enlightening! You might even want to create an annual favourite things page that documents changes in a child's life.

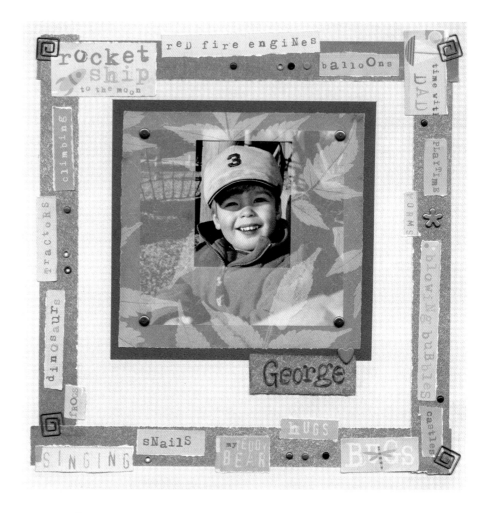

laura *opposite page, top*
cardstock: Bazzill Basics
paper: Creative Imaginations
vellum: Hot Off The Press
tag, brads and eyelets:
Making Memories
skeleton leaves:
Meridian Import Company
accent: EK Success

clare *opposite page, bottom*
cardstock: Bazzill Basics
paper: Creative Imaginations
vellum: Hot Off The Press
tags, brads and eyelets:
Making Memories
wheat: Meridian Import Company
accent: EK Success
font (Times Roman)
title: hand lettered

Giselle executed the same layout in two colour schemes. Each page features a strong photograph. Both include information about the girls' names and items from nature, wheat and a leaf. This is a wonderful example of how a single design can be modified for different looks.

On one page, the natural accent is under the vellum. On the other it is on top. Both are positioned overlapping the vellum to bring them into the overall design of the page and to accent the photos.

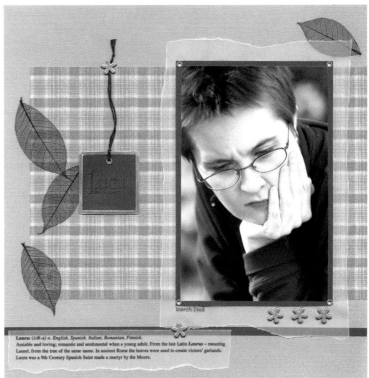

Laura: (loR-a) n. *English, Spanish, Italian, Romanian, Finnish.*
Amiable and loving; romantic and sentimental when a young adult. From the late Latin *Laurus* – meaning
Laurel, from the tree of the same name. In ancient Rome the leaves were used to create victors' garlands.
Laura was a 9th Century Spanish Saint made a martyr by the Moors.

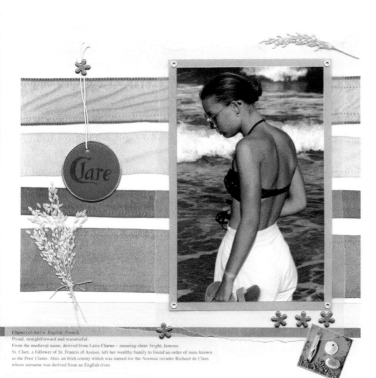

Clare (cl-Air) n. *English, French.*
Proud, straightforward and resourceful.
From the medieval name, derived from Latin *Clarus* – meaning clear, bright, famous.
St. Clare, a follower of St. Francis of Assisi, left her wealthy family to found an order of nuns known
as the Poor Clares. Also, an Irish county which was named for the Norman invader Richard de Clare,
whose surname was derived from an English river.

teaching / learning *top*
paper: EK Success,
K&Company
heart clip and eyelets:
Making Memories
quotation: K&Company
accents: EK Success
fibre: Texere Yarns

The title of this layout is
particularly appropriate because
Giselle's daughter Laura, seen
here in the picture with her son
George, is a junior school teacher.

The heart accent is wrapped with
extra fibre and slightly elevated
relative to the other accents. This
is a simple but effective way to
add interest to an accent.

You can also customize an accent
by adding micro beads, glitter,
embossing powder or a three-
dimensional glue like Diamond
Glaze. Or you could alter the
accent's colour by painting it with
walnut ink or acrylic paint. ⦿

george's 2nd birthday *bottom*
cardstock: Bazzill Basics
paper: Creative Imaginations,
Hot Off The Press
vellum, metal washers, buckle,
eyelet: Making Memories
paper raffia
title: hand-lettered

A closely cropped photo
commands our attention. We
know instinctively that there is
more of George than meets the
eye, but the tight focus demands
that we notice his expression.
Giselle inked the bottom of
her torn photo mat because
the white edge would have
been distracting.

tip Try paper raffia instead of
ribbon for a masculine look. Twill,
twine, string, or a strip of leather
looks good on manly pages. The
selvage edge of fabric also has an
interesting look which may be
more rugged than the actual
material itself.

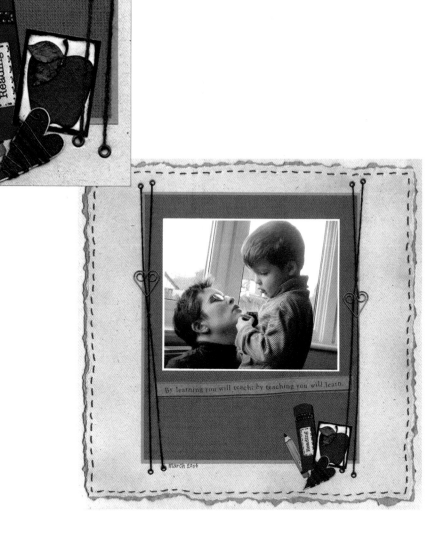

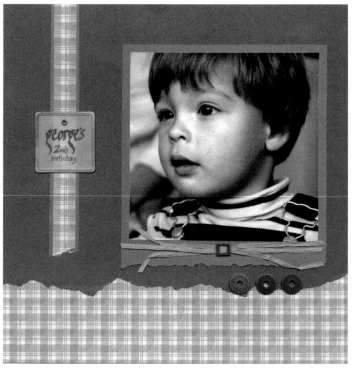

carrie howard

CAMBERLEY, SURREY

'The Internet provides me with a wealth of information and ideas,' says Carrie. She checks the UKScrappers site (www.ukscrappers.co.uk) every day to keep up-to-date on what's new and happening in the scrapbooking world.

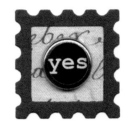

our engagement

paper: 7gypsies, Rusty Pickle
cardstock: Bazzil Basics
die-cut lettering (Katie): QuickKutz
die-cuts: QuickKutz
journey tag: Rusty Pickle
photo corners, metal frame, charmed plaque, eyelets, bookplate: Making Memories
conchos

This is Carrie's favourite layout, and it's easy to see why. Inside the folded letter, is 'The story of our engagement.'

She writes: *Neil suddenly said out of the blue, 'How much do you love me?' I didn't say anything, just stretched out my arms wide and indicated a 'this much.' So then I asked him the same question. His reply was, 'I'll show you.'*

Then he presented her with a ring.

Be sure to include dialogue in your journaling. Not only does dialogue add visual interest, it gives the reader a better sense of the people involved. Carrie doesn't just tell us the story; she shows us what happened so we can share her special moment.

tip Support your metal accents. Metal embellishments such as the frame, the heart plaque, and the heart are relatively heavy for a scrapbook page. You'll want to mount your page on cardstock so the accents don't tear or cause the page to sag.

The concho (upper right) with the word 'yes' inside would have gotten lost in the patterned paper if it hadn't been surrounded by the postal stamp frame. Putting a frame around any element will emphasize it. In this case, the contrasting colours—brown, beige, black—also add drama.

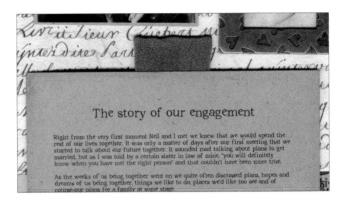

The story of our engagement

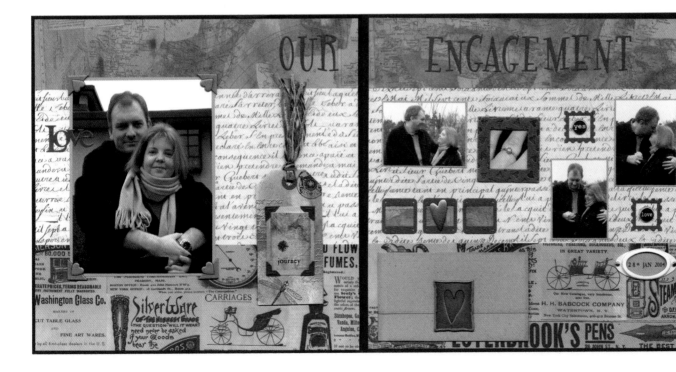

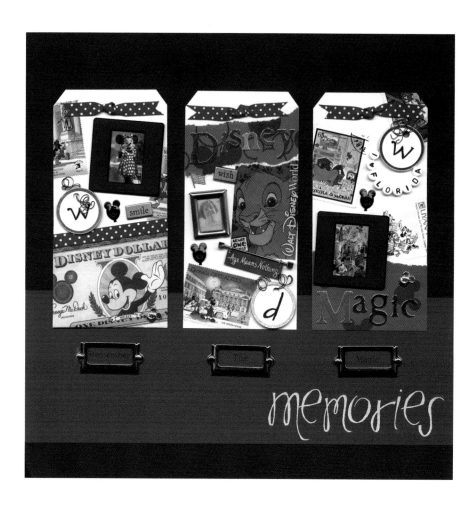

21st birthday *opposite page, top*
cardstock: Bazzill Basics
die-cut lettering (Venus): QuicKutz
stickers: EK Success
font: Scrapbook Chinese
mulberry paper
fibres

Carrie layered Oriental embellishments over paper patterned with large Chinese characters. It's a fun combination. The fringe of the red mulberry paper makes for a soft transition against the black. All the letters of 'birthday' have a narrow black mat, an especially important touch that keeps the letter 'B' from disappearing against the red background.

tip Notice the small Chinese script above and below the journaling box? It helps frame the words. Check the script out at www.ontariolive.com/jole-fonts/usingsc.html. You could do the same with any script that isn't written with our standard alphabet like Russian or Arabic.

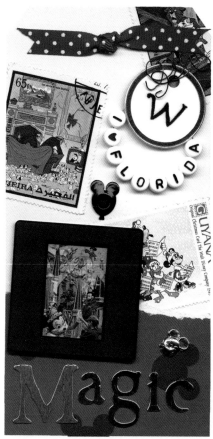

disney magic *top, left*
cardstock: Bazzill Basics
tag, eyelet letters, words, rub-on letters: Making Memories
slide mounts
eyelets
wire
charms
bookplates
ribbon
embellishments: 7gypsies
stickers: Creative Imaginations
mini frame: Scrapworks
alphabet beads
Mickey nailheads
white tags

Carrie managed to capture Disney's sensory overload with three tags full of fun. The tags are busy but surrounding them with solids keeps them from being overwhelming. The unifying element is the red polka dot ribbon tied at the top of all three tags. Check out the small round white tags labeled WDW for Walt Disney World.

calais *below*
cardstock: Bazzill Basics
foam stamps, acrylic paint, date
stamp: Making Memories
accents: EK Success
transparency

Scrapbooks don't have to be
12" x 12". These pages are
15.5 cm (6") square, a perfect
size for a special event album.
Carrie printed her journaling on a
transparency and then sewed the
transparency to her page. The
smaller size page is great for
displaying these Jolee's Boutique
accents by EK Success.

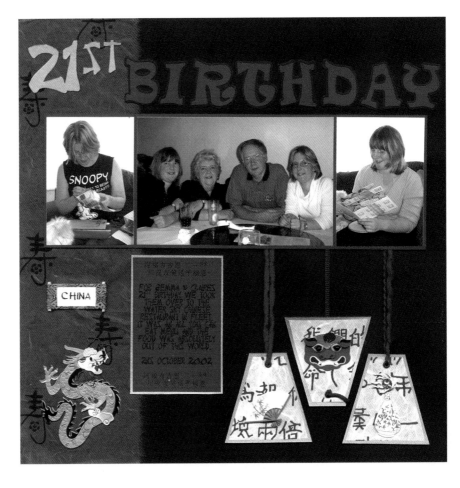

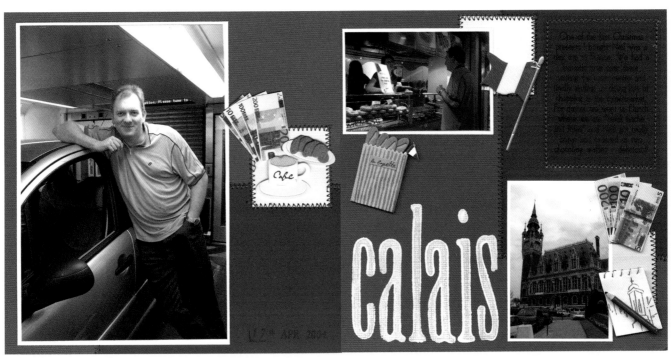

venessa matthews

RUISLIP, MIDDLESEX

Venessa immigrated to the U.K. from South Africa in 1999. Scrapbooking became a lifesaver for her. 'It helped me during a time of loneliness and homesickness to find and make new friends that share this passion with me,' she says.

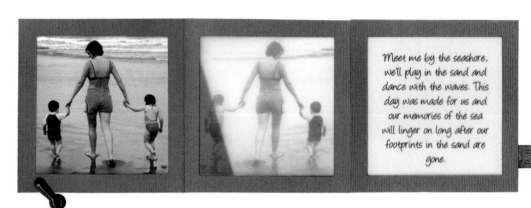

footprints
cardstock, vellum: Bazzill Basics
patterned paper: Deja Views
pen: Zig
journaling font (Angelina)
starfish stamp: Anita's Crafts
alphabet stamps: Hero Arts
watermark ink: Tsukineko
photo anchors, brads: 7gypsies
transparency

Venessa used a starfish stamp on her brown paper to underscore her theme. The soft stripes on the right look vaguely nautical, and they also serve to add movement to the page. Note the vertical page title 'Footprints.'

The poem reads: *Meet me by the seashore, we'll play in the sand and dance in the waves…our memories will linger on long after our footprints in the sand are gone.*

The colour photograph—first page of the booklet on the left when opened—is reprinted on vellum as the middle page. You can see the image through the journaling transparency when the booklet is closed.

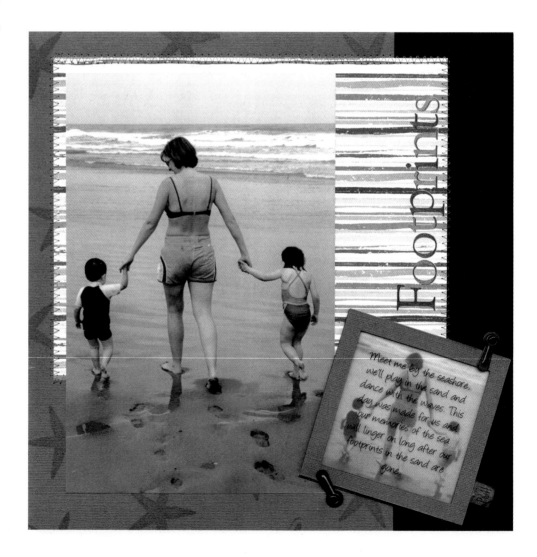

the beach

cardstock: Bazzill Basics, Making Memories
die-cut lettering ('the'): QuicKutz
metal tag, rub-on lettering: Making Memories
glaze: Diamond Glaze
watermark ink: Tsukineko
fibre, charm: The Bead Shop
foam stamp (seashell)

Venessa created a self-contained album for a very special memory of her daughter on holiday in South Africa. Imagine what a brilliant gift this would make! The album closes with a piece of twine on which a starfish charm hangs. The scallop shell design that appears on the outside cover, inside right cover and page title is stamped in watermark ink, an ink that leaves a simple shadow impression without adding colour. Also note her copy—it describes specific activities and ends with a wish from mother to child, 'May you never take one moment of this life you are given for granted.'

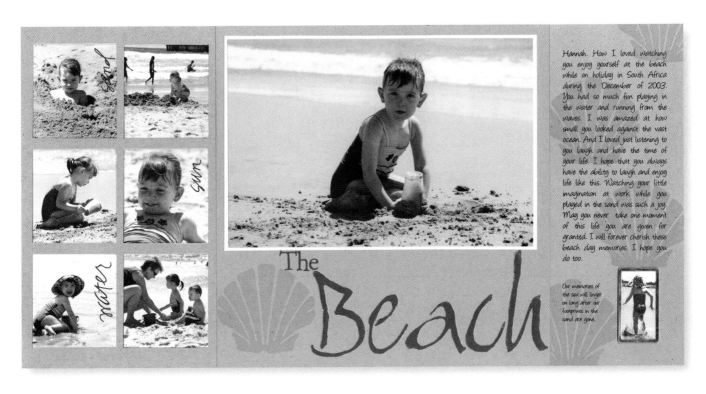

Hannah. How I loved watching you enjoy yourself at the beach while on holiday in South Africa during the December of 2003. You had so much fun playing in the water and running from the waves. I was amazed at how small you looked against the vast ocean. And I loved just listening to you laugh and have the time of your life. I hope that you always have the ability to laugh and enjoy life like this. Watching your little imagination at work while you played in the sand was such a joy. May you never take one moment of this life you are given for granted. I will forever cherish these beach day memories. I hope you do too.

Our memories of the sea will linger on long after our footprints in the sand are gone.

The Beach

beauty

patterned paper, alphabet
stamps, safety pin, ribbon,
buttons, brad, flower:
Making Memories
flower charm: The Bead Shop

Venessa lightly sanded the edges
of her paper to give it a softer
look. She followed three stripes
down the page with her craft
knife, cutting them free. Then she
slipped her photo under two of
the stripes and over the middle
stripe of paper. Her embellish-
ments are attached to the
free-standing stripes.

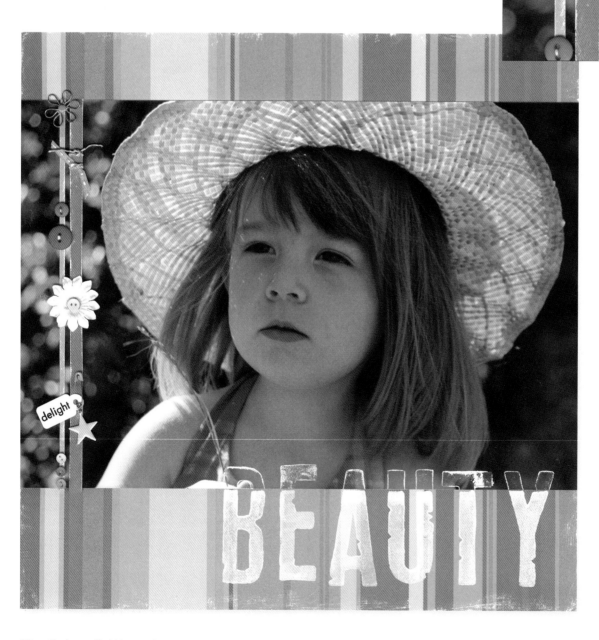

anne parry

BUSHEY, HERTFORDSHIRE

Anne is a police artist who does scrapbooking 'for the creative element.' She loves looking in unusual places for unique items—like earrings and other jewellery—to use on her pages.

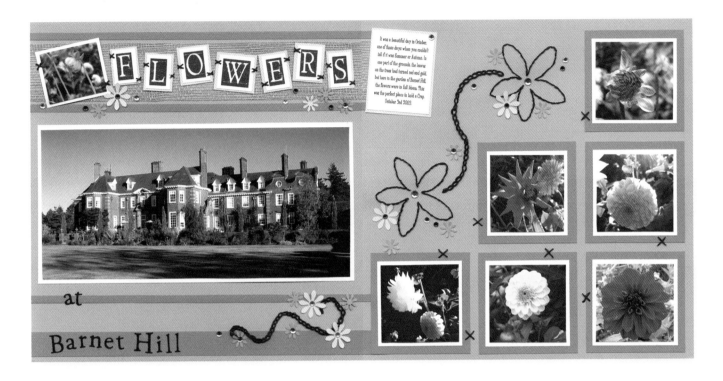

flowers at barnet hill
cardstock: Bazzill Basics
die-cut lettering (Paige): QuicKutz
flower punch
faux jewels
embroidery thread
green mesh
font (Smargana)

Anne wanted to savor a beautiful October day 'when you couldn't tell if it was summer or autumn.' Her close-up photos of the flowers along with the wide view of the house make us feel like we were there, too. And we could have been, because she was visiting for a crop!

The flowers are joined with a chain stitch of green embroidery floss. Anne uses floss again in the tiny 'X's on her letter tiles and on her right page photos. The petals of the flowers are gently curved up to add dimension. The faux jewels add a bright note.

tip Create holes for your stitches before you start sewing. Poke the paper from the right side (front) to the wrong side (back) for a neater hole. Use a needle about the same thickness as your thread so that your thread completely fills the holes.

tip Be adventurous. You own a lot more scrapbooking supplies than you think. Anne says, 'I don't tend to stick to just scrapbooking products. For instance, if I want paint, I'll use the stuff I paint my walls with.'

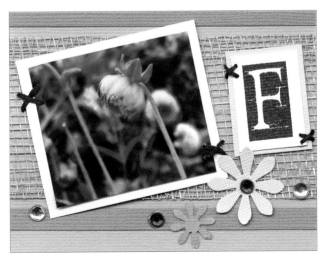

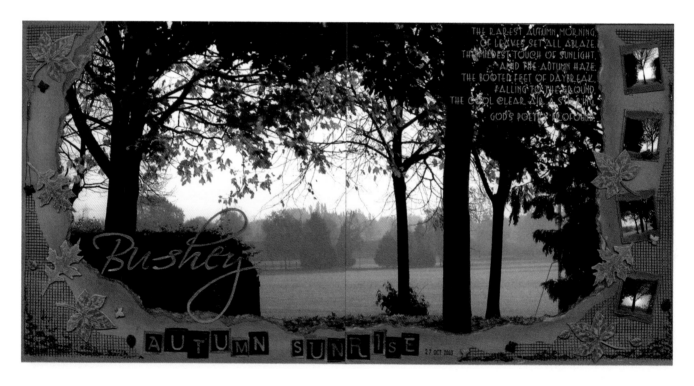

bushey
cardstock: Bazzill Basics
copper sheet
copper wire
beads
chalks
leaf buttons
mesh: Magic Mesh
copper leafing pen: Krylon
clear ink pad, embossing powder
leaf stamps
date stamp
fonts (Scriptina, Lemon Chicken)

Anne discovered photography at age ten, and today she carries a camera with her at all times. Here her glorious photo of a sunrise has been enlarged to fill two pages. Smaller photos of the sunrise serve as parts of her border. The page title was hand cut, coloured with the copper leafing pen, and then embossed. With a copper leafing pen, Anne added this poem by Linda A. Copp:

The rarest Autumn morning
of leaves set all ablaze.
The mildest touch of sunlight,
amid the autumn haze.
The booted feet of daybreak,
falling to the ground,
the cool clear air a stirring
God's poetry profound.

Anne wrapped copper wire around the small leaf beads to hold them onto the torn paper border. A few beads are strung through the copper wire that stretches from one piece of mesh to another. More beads are glued into the mesh at the bottom of the page.

tip Use a border of torn paper and mesh like this to frame a large photo. Include small squares of the large photo or cut from the large photo. Anne matted her small square photos. The mat on the top and bottom edge of the photos is torn.

a portrait of me
cardstock: Scrapbook House
patterned paper: 7gypsies
collage paper: Paper Reflections
labeling tape: Dymo
sticker lettering: Doodle Bug
Design, Me and My Big Ideas,
Sonnets, Real Life
rub-on lettering: Making Memories
paper flowers and ribbon charm:
Making Memories
brads
embroidery thread
ribbon
pastels: Inscribe
acrylic paint

Anne's current favourite technique
is collage. It reminds her of
childhood scrapbooks and diaries.
She makes a point to always
include a sketch or two. These
were drawn with an ink pen.
Because its style can be so
playful and eclectic, collage is
the perfect place to debut your
own sketches.

Look closely at all these glorious
textures in the postcard extraction
(see below): embroidery stitches,
silk flower, antique paper, velvet
ribbon, lace, charms, ripped
photo edge and plastic Dymo
labeling tape. Anne has added

layer after layer of interest while
telling the compelling and wistful
story of missing her grandparents.

tip Brush acrylic paint onto
patterned paper to form a solid
backdrop that keeps your accents
from being overwhelmed. Anne
used this technique to make her
sketches stand out.

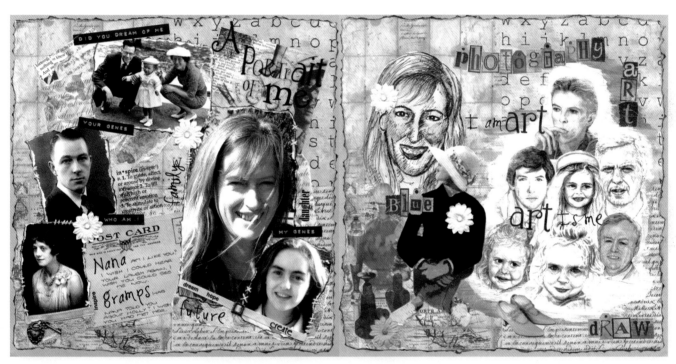

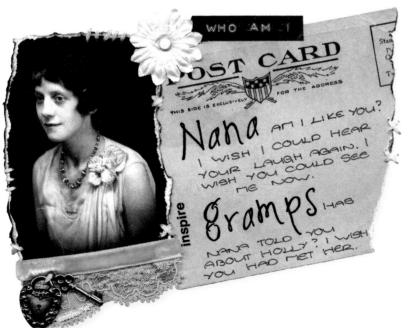

alison penstone

BRACKNELL, BERKSHIRE

Use your stash. Don't hang on to that gorgeous piece of paper waiting for 'the perfect layout' to come along—if it fits with what you're doing, use it. There will always be another gorgeous piece of paper to buy tomorrow! AP

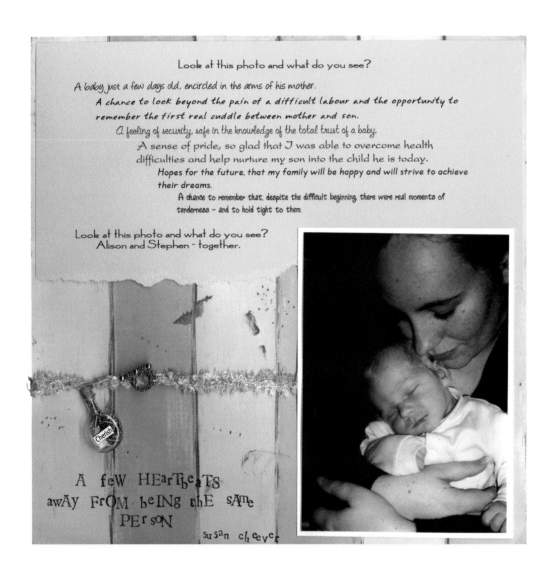

a few heartbeats away
cardstock: Bazzill Basics
patterned paper: Rusty Pickle
fibres
clasp: Wiggly Woods
glass bottle: 7gypsies
magnetic word: Fridge Poetry
rubber stamps:
Hero Arts and PSX
font (Squish):
Two Peas in a Bucket
fonts (Angelina, Annifont,
Libbyscript, Hansa, Short Hand,
Ziggy Zoe)

This is Alison's favourite layout. She says, 'It was the first time I had journaled about a very difficult time, and I found it really therapeutic to see I had come through to the other side.' When journaling about a challenging time, go slowly. First get all your thoughts on paper. Let your writing sit for a while. Then go back and decide what you want to share and how you want to share it. You might decide to 'hide' more private journaling in a pocket so that it is not available for casual viewing.

Alison's journaling chronicles her triumphant journey, 'Look at this photo and what do you see? A baby just a few days old, encircled in the arms of his mother. A chance to look beyond the pain of a difficult labour.... A sense of pride, so glad that I was able to overcome health difficulties and help nurture my son....'

tip Safeguard breakable accents (like tiny glass bottles) when you add them to your scrapbook. If you know you will be adding a lot of 3-dimensional items, trim your background paper a little—the smaller dimensions will give the layout more room inside its page protector. If the embellishments you add are breakable, check out the Protect-A-Page by Dolphin Enterprises. You can also protect your breakable embellishments with a 'buffer' page. You can make a 'buffer' page by gluing a piece of plastic bubble wrap to a page protector. Put buffer pages on each side of a heavily embellished page.

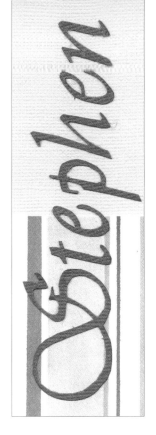

stephen *top*
cardstock: Bazzill Basics
patterned paper:
Making Memories
transparency: Dataline
brads: Happy Hammer
hinges: Magic Scraps
fonts (Spirit, Vivaldi, Alison's Hand)

The hinged photo hides heartfelt journaling. 'When you found the water feature on the wall at Jenny and Dave's house…you were entranced by it…. As you get older, I hope you always find the time to see the small things in life. It's so easy to get bogged down by problems and arguments,' reads Alison's message to her son. Your journaling should leave a legacy, a legacy of your hopes and dreams for those you love.

tip Hinge a photo and put your journaling on the inside flap. Compare this hinged photo to Mandy Anderson's **Always in My Heart** on page 5. In both cases, the integrity of the design is unencumbered because the journaling is hidden away.

tip Alison had her handwriting made into a computer font, Alison's Hand. Go to www.fontifier.com for details.

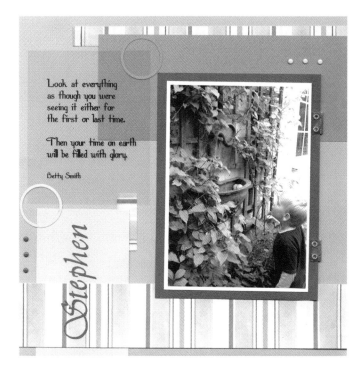

summer *bottom*
cardstock: Bazzill Basics
patterned paper: Chatterbox
vellum: Barking Dog
buttons: Junkitz
embroidery floss: DMC
rub-on words: Making Memories
brads: Wiggly Woods
labeling tape: Dymo
ink: Clearsnap, Inc.
font (Angelina)

Here's a clever way to label the people in your photo. Alison used Dymo tape and spaced the children's names around the picture roughly adjacent to their images. Alison journaled her hopes for the children: 'As you grow older, I hope you continue to value this friendship as much as your mums have.' Many scrapbookers get stuck trying to journal about the photo. Instead, journal about the people in the photo, not the specific situation that's pictured.

tip Run thread through your button holes for a dash of colour and texture. Alison used contrasting thread on the middle button for extra interest.

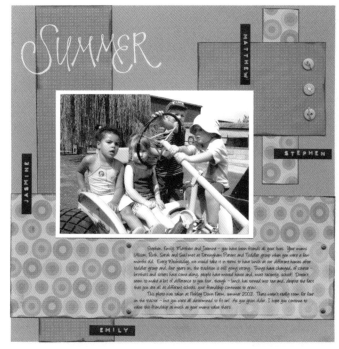

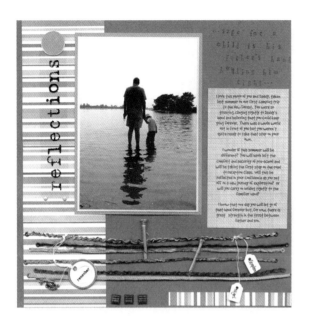

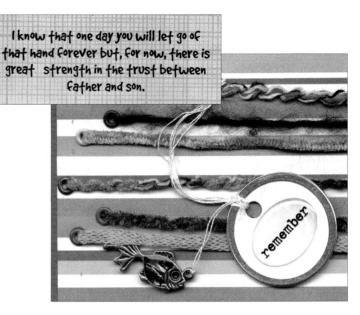

I know that one day you will let go of that hand forever but, for now, there is great strength in the trust between father and son.

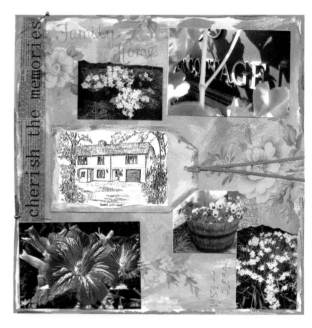

remember

reflections *above*
cardstock: Bazzill Basics
patterned paper: Chatterbox
transparency: Dataline
brads: The Happy Hammer
fibres: Fibres by the Yard
embroidery floss: DMC
tags: (tiny) Staples, (circular) ScrapMagic
mirror: Hobbycraft
bubble phrase: L'il Davis Designs
charm
bamboo paper clips: Jest Charming
alphabet stamps: Hero Arts
ink: Clearsnap, Inc.
fonts (Harting, Good Dog Plain)
mosaic tiles: Wiggly Woods

You don't have to restrict your journaling to plain cardstock or paper. Alison printed her journaling on patterned paper that perfectly compliments her page design. ✿ The staggered design of the eyelets on the left and right sides of the page are much more interesting than if the eyelets were lined up. Running fibres across the bottom of the page adds interesting texture and gives Alison a place to hang her tags.

Alison wrote, 'You were so trusting, clinging tightly to Daddy's hand and believing that you could keep going forever. There was a whole world out in front of you but you weren't quite ready to take that step on your own.' Writing directly to another person, using the second person (you, yours), has a very natural and intimate sound.

family home *right*
cardstock: Bazzill Basics
paint: Anita's Acrylics
patterned paper: Daisy D's
transparency: Karen Russell Narratives
ribbon: Hobbycraft
pearl-headed pins: Wiggly Woods
pen: Zig

Alison painted her background cardstock—which was originally beige—with acrylic paint in shades of rose and pink. She did the same with her tag, bordering it with a deeper rose. After deciding where her photos and the tag would go, she strategically placed roses cut from patterned paper onto her background. Notice the unusual photo angle of the word 'Cottage.' Unique angles make for interesting photos. Try standing to one side or lying on the ground and shooting up at your subject. When photographing children, it helps to get down to their eye-level.

tip Freeze your acrylic paints if you have to stop while using them. Just cover your paint brush and paint with plastic kitchen wrap and stick the whole mess in your freezer. This keeps the paint from drying up. Defrosting only takes a few minutes and you can start where you left off.

tip Sharpen your scissors regularly. If the paper tears or frays when you cut around corners, it means your blades have gone dull.

ali rowe

ASCOT, BERKSHIRE

Ali creates every page trying to imagine what the recipient will feel in ten or twenty years when they look at it. She challenges herself to think, 'Will they understand my journaling? What I felt? What was going on at the time? Why I used this photo?'

cousins
cardstock: Bazzill Basics, SEI
patterned paper: Paper Fever
tin tiles: Making Memories
alphabet stickers: Sue Dreamer
charm bracelet: Accessorize
diamante charm ('M'):
Daniels of Windsor

When Ali's daughter Molly bought herself a bracelet that proved too big for her, she said 'Can you use this on your layouts, Mum?' and the idea for this page was born. Ali attached the bracelet to the page with brads, but she has also used KI gloo or Making Memories metal glue.

tip Before starting your machine stitching, make sure you have plenty of thread in your bobbin and on your spool. If you run out of thread, it will be impossible to go back and stitch in the holes your needle has created. Consider varying your stitches, using both straight and zigzag.

tip Try including something with special meaning as a sort of signature in all your layouts. Ali puts the initial 'M' in every layout as you see the charm (right). You could also create a code using symbols. A heart could mean, 'I love you.' A star could mean, 'I'm proud of you.'

Ali became a fan of landscape layouts after she discovered an SEI album called Molly. Of course, she just had to have it. After filling a whole album with landscape layouts, she began filling regular portrait albums with a mix of portrait and landscape layouts. Landscape layouts make a refreshing departure from the more usual portrait pages.

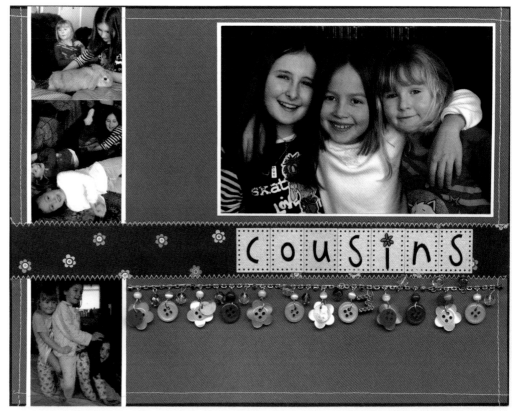

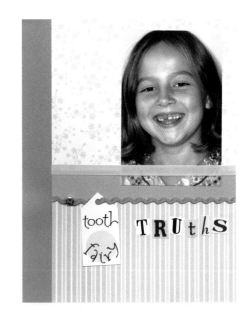

molly aka *below*
cardstock: Bazzill basics
Japanese textured cardstock:
unknown
paper: Chatterbox, KI Memories,
Anna Griffin, Rusty Pickle, Jone
Hallmark, Kopp Design, Sandylion
mulberry paper
silk flower
microbeads
charm (girl)
rickrack and ribbon: John Lewis
metal tag: Happy Hammer
alphabet beads: ELC
letter stickers:
Wordsworth and Provo Craft
brads, silk flower, metal letters:
Making Memories
hugz and alphadotz: Scrapworks
envelope accent and photo
corner (butterfly): EK Success
charm (monkey):
Claire's Accessories
alpha brads: Carolees Creations

tip Include unusual photos in
your layouts. Scrapbookers seem
to gravitate toward 'pretty'
photos, but pictures like this are
equally delightful because they
reveal so much personality. In
fact, this is one of Ali's favourite
pictures of Molly because it
highlights her playful side.

tip Make a list of your loved
one's nicknames. Nicknames tell
the story of our affection, and they
deserve a place in our scrapbooks.

tooth fairy truths *right*
cardstock: Bazzill Basics
patterned paper: Chatterbox
rickrack and ribbon: John Lewis
bead ('M'): Daniels of Windsor
letter stickers: Wordsworth,
Pebbles Inc.

Molly had asked the Tooth Fairy to
write to her and to leave her a
picture of herself. Ali knew it was
only a matter of time until Molly
learned the truth. Ali wrote,'I
hated lying to you. I guess that all
parents do it, but as you're
getting older and we talked about
our values, and how important
truth is, it seemed hypocritical to
keep going (with the myth of the
Tooth Fairy).' Ali tucked all the
relevant correspondence in a
pocket under the left edge of the
patterned paper.

tip Journal about your
ambivalence. Our children will
face difficult problems, both large
and small, in their lives. Knowing
that we, too, struggled for
answers will help them so they
don't feel so alone.

tip Keep your child's original
notes or artwork. If they are too
large to put in a pocket, colour
copy them, and shrink them to a
more manageable size.

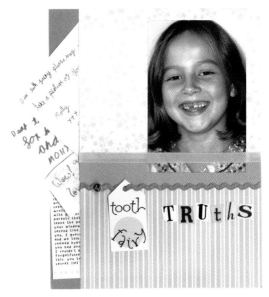

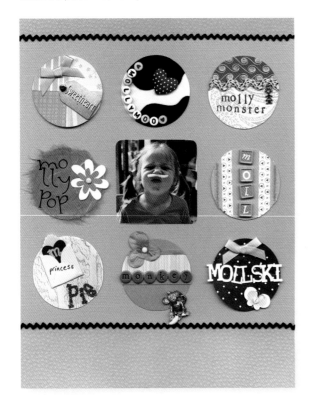

things you love (age 6)
cardstock: Bazzill Basics
patterned paper: Chatterbox
twill: 7gypsies
slide mount
typewriter keys
ribbon: John Lewis
textured stickers: Sticker Studio
photo anchors and brads:
Making Memories
alphabet stamps: PSX
fonts (Harting, Blockup, Alaskan
Nights, 2Peas Silly Fill-in, 101
Starlit, Licorice Strings, Viney
Times, GM Friends, Submerged,
Popstars, Lemon Chicken,
rollergirls, Easily Amused,
Bellbottom, Chinese Takeaway,
Fontdinerdotcom, Simpson,
4990910, Cupcake)

The word 'you' is rubber
stamped, and the phrase 'AGE 6'
is created from stickers, but all the
other words are computer
generated and then printed.
Compare this page to page 14
where Giselle Homer tells us
about her grandson **George's
Favourite Things**. Both use list
making as a journaling technique.
Both are crammed with informa-
tion about preferences that will
change as the children grow.

tip Show off your stash of fonts
with a page of lists. Ⓦ

tv junkie _below, right_
cardstock: Bazzill Basics
patterned paper: Chatterbox
ribbon: Making Memories
mini frame: 7gypsies
letter stickers: SEI
capital letters on acetate:
Carolees Creations
font (Adler)

This photo mat serves as the
background for the journaling. Ali
writes to her daughter that on
weekends the television stays on
for at least all of Dick & Dom in Da
Bungalow. Then Ali adds, 'You tell
me it is educational. Hmmmm...'

This interchange is an example of
excellent journaling. Notice that
instead of a generalization like 'the
television is always on,' Ali tells us
when the television is on, what it's
tuned to, and her daughter's
ready comeback when confronted
with parental disapproval.

tip Add specific details to your
journaling to make what you write
much, much more vivid. We
remember details, not broad
generalities. One way to be more
specific is to be aware of your
word choices.

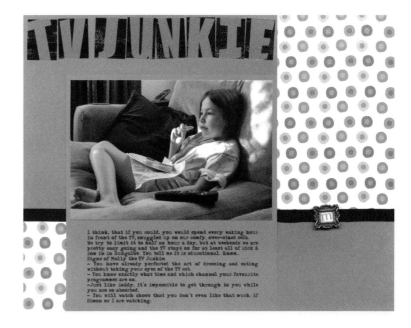

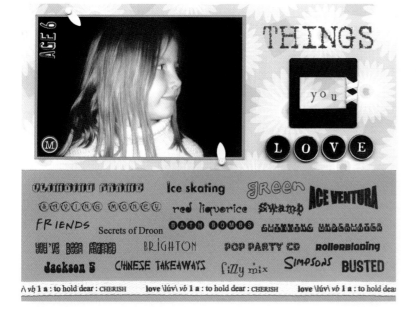

michelle thompson

SOMERSHAM, CAMBRIDGESHIRE

Scrapbooking for me is the only pure spiritual chance to relax. When I scrapbook, I can disappear into myself for hours on end, not thinking about anything. It is bliss. MT

generations, time, family
cardstock
gold vellum
accents: DooDads
buttons
feathers
metallic gold thread
embroidery floss
foam tape
gold gel pen
photo tinting pen: Zig Photo Twins

The entire background for this layout was pieced together from three little ethnic bags Michelle purchased at a local market. Her first challenge was to cover the blank spaces with her photos while still displaying the beautiful beads, mirrors, sequins, and gold stitching. Her next problem was making sure her photos didn't get lost.

Her solution was to convert her photos to black and white and surround them with gold frames. She did all this in PaintShop Pro7. After printing her photos, she highlighted parts of them with a photo tinting pen.

Michelle wrote her journaling first in pencil and retraced it in black ink and gold gel pens. The gold vellum is hand-stitched with embroidery floss.

tip Add a feather for a rich texture unlike any other accent. Here Michelle tucked a feather into her embellishments. It's a small touch that adds drama. You will also want to include buttons in your list of embellishments. The tiny clock buttons repeat the theme of time.

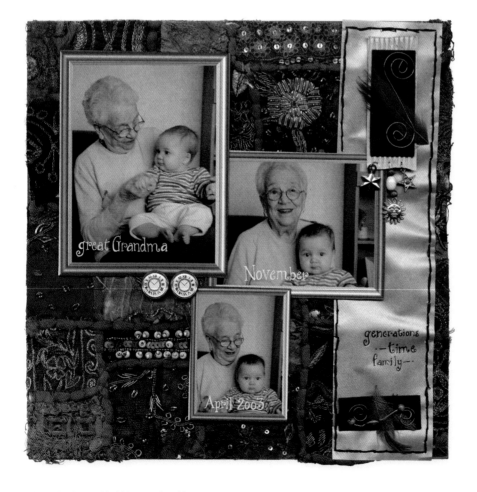

family christmas 2003
cardstock: Creative Imaginations
paper: Paper Adventures
accents:
Jane Dean for ScrapMagic
stickers: EK Success
gold leaf pen: Pentel
foam tape
gold metallic thread
fonts (Paris, Alfredo's Dance)

Michelle used a digital program to age her photos and give them a soft look. She crumpled the red crackle paper and then smoothed it, using it like a ribbon on the large page title tag.

Photos, accents, and Christmas lights form a border at the bottom of the page. By varying the height of the photos with foam tape, Michelle was able to weave the strand of Christmas lights (which are actually stickers) under them.

tip Mat fibres for extra impact and texture. The gold thread used to hang the tags here reappears running across the top of the page and matted with the red crackle paper. Whenever possible, use the rule of threes and introduce an accent to your page three times. Here those three appearances of gold thread include tag ties, hanging cords for the stars, and a left-to-right page accent.

tip Colour your torn paper edges. When ripped, some papers reveal a white core. If you don't want to include white in your design, colour the torn edge with inks or chalks. Michelle used gold to harmonize her layout.

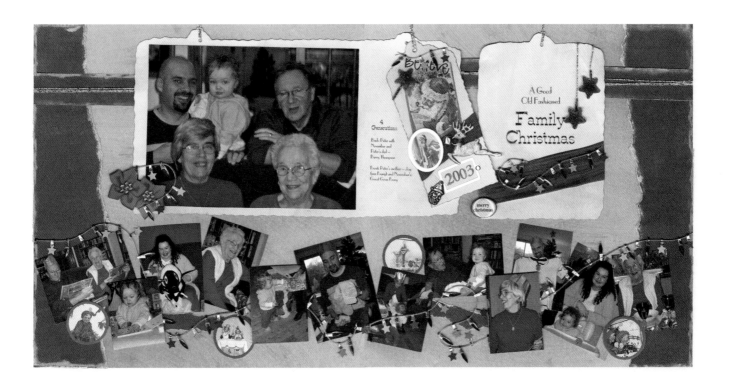

miles *right*

cardstock: Bazzill Basics
corrugated cardstock:
Hot Off the Press
collage papers: Paper Reflections
patterned papers: Scrappychic,
Me and My Big Ideas
Maruyama paper
splatter net: Jest Charming
alpha brads: K&Company
eyelets
charms: Wiggly Woods
dog tags
shipping tags
copper metal sheet, clips:
Making Memories
transparencies:
7gypsies, MagicScraps
gold thread
rubber stamps: PSX, Hero Arts

'Peter travelled from Cambridge,
England, to Wellington, New
Zealand, for a new job and a new
life. In that job was me!' writes
Michelle. This hedonistic collage
represents the long journey this
couple made toward
commitment. The dried flowers
were taken from Michelle's
wedding bouquet.

More of Michelle's journaling:
*Since the wedding, our love is
now not counted in miles, but in
little steps and changes on a
daily basis.*

Note how she tied her journaling
to the theme of her layout.

tip Begin building your collage
with a theme in mind. Many
scrapbookers shy away from
collage because they find it
overwhelming. Focusing on one
topic can help you narrow down
your accent and paper choices to
create a cohesive message.

tip Consider tag/pocket
journaling. It's easy to get caught
up in design and then discover
you don't have room for your
journaling. Instead of leaving out
your story, write your journaling on
a tag and put it inside a pocket or
behind a design element. Look
back at Mandy Anderson's
Reflections of My Love on
page 6 for another example of
tag/pocket journaling.

june 15 *below, right*

transparencies and stickers:
NRN Designs
vellum
white gel pen
ladybug sticker

Michelle took this picture of her
daughter November in her new
bathing suit on what was her
husband's first Father's Day.
Turns out the little bikini top,
'oh-so-cute' in the photo, was not
that practical once in water and
November never fitted it again.

Transparencies are a relative
newcomer to the scrapbooking
industry. Here their see-through
properties are used to great
advantage as strips and circles of
green and blue are overlapped to
frame November's photo.

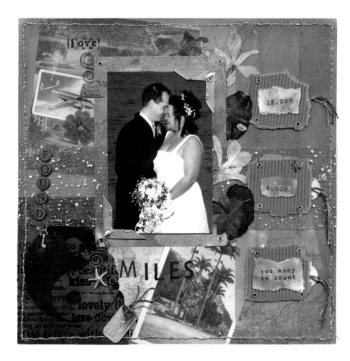

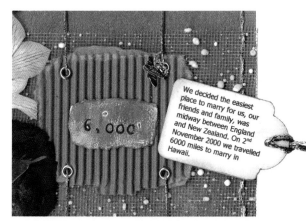

sarah wheatley

HURSTPIERPOINT, WEST SUSSEX

Scrapbooking was made for me; it allows me to preserve my photographs, document why I took them, and to be creative at the same time. SW

blur
cardstock: Bazzill Basics
brads, eyelets, twine:
Making Memories
mesh: Magic Mesh
Pop Dots: All Night Media
transparency
font (Blackout):
Two Peas in a Bucket

Sarah's son Alexander was whipping a tree branch around when she snapped this photo. The motion became a metaphor for a young man on the move.

To create the word 'blur' in white, Sarah used MicroSoft Word. First, she created a text box. Next she typed in the word in an outline style font. Then she changed the text to white. Since the printer does not contain white ink, this works like a mask. The original colours of the photograph appear in the centre of each letter.

tip Store your memory albums on end. If you lay them flat, heavy items may cause indentations, and Pop Dots can go flat. Luckily, the Pop Dots and foam tape will fluff up again, but the indentations may not.

tip Fake an envelope closure. Punch out two circles, attach them to your paper with eyelets, and wrap twine around them in a figure 8 pattern as shown.

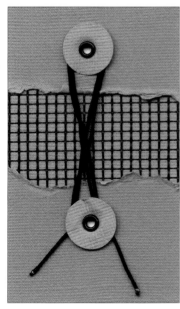

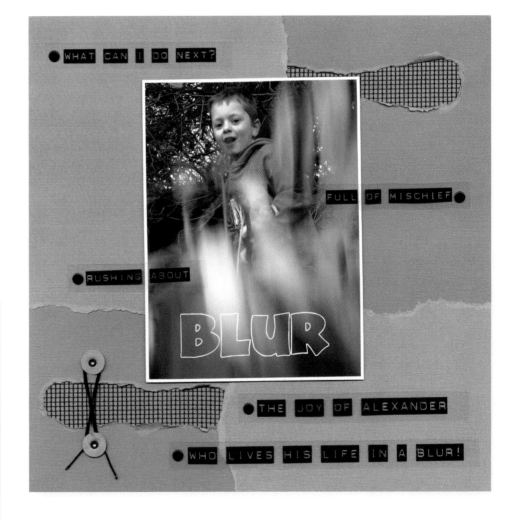

WHAT CAN I DO NEXT?

FULL OF MISCHIEF

RUSHING ABOUT

BLUR

THE JOY OF ALEXANDER

WHO LIVES HIS LIFE IN A BLUR!

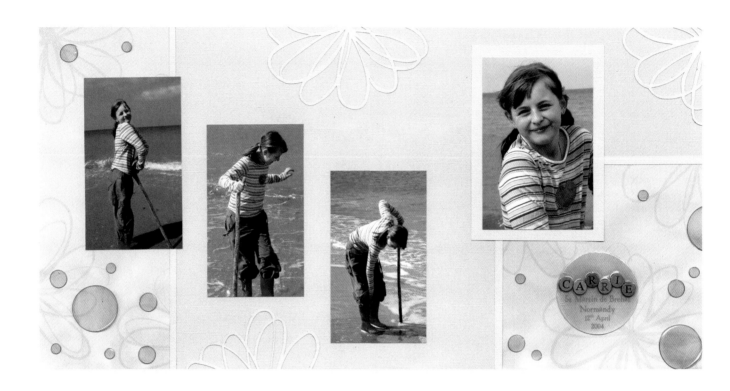

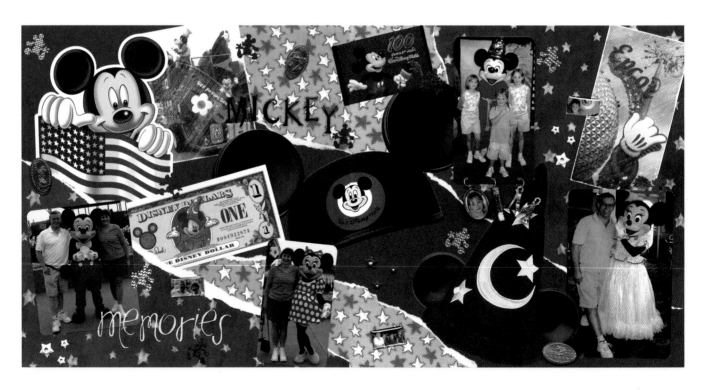

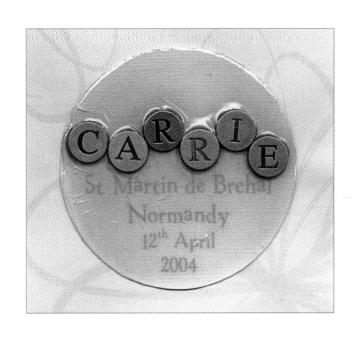

carrie *opposite page, top*

patterned paper:
KI Memories
wire
Diamond Glaze
eyelet lettering: Making Memories
font (Chestnut):
Two Peas in a Bucket

Sarah created the large open flowers on her background. First, she made photocopies of the flowers on the patterned paper. Next, she adhered the photocopies to the back of light green cardstock. (A temporary adhesive is a must for this step.) Then she carefully cut out the flower designs with a craft knife and attached them to the layout.

Her transparent circles are equally ingenious. Sarah formed wire circles of various sizes, laid them on the paper, and filled them with Diamond Glaze. For the title circle, she first printed out the words on cardstock and positioned eyelet letters above her text. The final step was flooding the circle with Diamond Glaze.

tip Try using Diamond Glaze to make your own embellishments. (Diamond Glaze is the name of a three-dimensional liquid glue that hardens to a glass-like finish. A similar product is called Crystal Lacquer.)

mickey memories
opposite page, bottom

cardstock: Bazzill Basics
patterned paper: Karen Foster, Making Memories
page pebbles, eyelet letters, eyelet stars: Making Memories
charm frame: Embelleez
glass bottle: 7gypsies
rub-on words: Making Memories
letter stickers: Stickopotamus
squashed pennies, Disney dollars, Mickey Mouse shapes, passes, postcards: Disney
Pop Dots: All Night Media
beads
clear embossing powder

Eyelet stars and small Mickey Mouse shapes dot this layout. Sarah also included pressed pennies and other memorabilia. She cautions new scrappers, 'Don't spend a fortune on bits and pieces when you first start out. Most of my favourite pages are created with cardstock, adhesive and a computerized font.' Here she splurged a little to add charms, rub-on words and letter stickers.

tip Collect as much ephemera as possible when you travel. Ephemera are items not intended to have lasting value. Such items might include brochures, maps, receipts, fliers, menus, schedules, ticket stubs, postcards, passes, wrappers, tray liners, notices, programs, stamps, coupons, gift cards, bookmarks, shopping bags, labels, and packaging. You never know when one of those pieces of ephemera will be just perfect in a layout.

tip Vary the way you attach small bottles to your layouts. You can wrap wire around them, glue them on, or thread fibre through the hoop in the stopper. You can also use a jump ring like Sarah did here. Another possibility is wrapping fibre around your bottle, but if you do, you might want to use a dab of glue to keep the fibre from slipping.

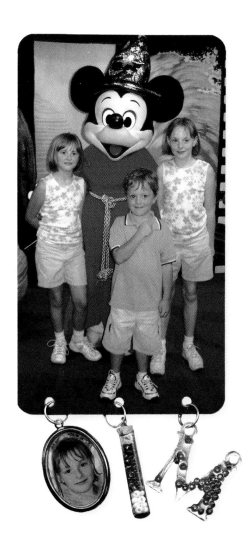

debbie wood

SURBITON, SURREY

'I love stationery, scrapbook supplies, and cameras, so scrapbooking is the perfect hobby for me,' says Debbie. But it's more than that: scrapbooking is also her business. In 2001, Debbie opened the first dedicated scrapbook store in the UK, ScrapMagic.

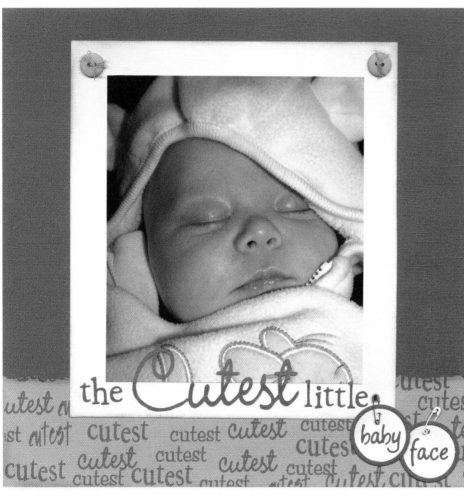

dream *opposite page, top*
paper: Creative Imaginations, Glad Tidings
vellum: Bazzill Basics
tags and rub-on words: Making Memories
poemstones: Creative Imaginations
fibres: Adornments, EK Success
beads: Embelleez
circle clip: Boxer Scrapbooks
chalk: Craf-T Products

Using a rectangle of vellum to mute the photos and the patterned paper, Debbie brings focus to her sleeping daughter, Jessica. The soft colours and the blur of the vellum are indeed dreamy. Note the beads strung on wire and crisscrossed at the far right edge of the top picture. Another wire strung with beads peeps through the fibres on the left side. Go to the *Page Gallery* on page 57 and look at **Ice Maiden** to see another example of Debbie's bead and wire technique.

baby face *above*
cardstock: Bazzill Basics
tag, letter die cuts: QuicKutz
chalk: Craf-T Products
safety pins: Making Memories
buttons: Bazzill Basics, Junkitz
fonts (Parade, Crafty, Wendy, Garamouche)

Debbie printed 'Cutest' in brown in a variety of fonts that she had downloaded from the Internet. 'I do have an A3 printer, which helps!' she says. Creating a custom background is a great way to use a large size printer.

The tags are fakes. Debbie used a QuicKutz die to cut the tags' rims out of cardstock. You can do the same with a circle cutter like the Circle Scissors by EK Success. Start by using a temporary adhesive to tack your paper securely to a glass cutting surface. Keeping your paper from slipping is critical. Next, cut the inner circle so that you have a hole in your paper. Then reset your blade to a large size and cut the outer edge of the ring.

The large word 'Cutest' in the page title was reverse printed on cardstock in Wendy Medium, then cut out with a craft knife. When you reverse print before cutting, you don't need to worry about whether the print lines show.

tip Experiment with safety pins. You can use them almost anywhere you'd use a brad or eyelet. You can also string them together to form a chain. Slip beads on them for a dash of color. Colour the heads with acrylic paint or ink.

pure enchantment *below*
cardstock and vellum:
Bazzill Basics
filigree flowers: Habitat
eyelet letters: Making Memories

This is Debbie's favourite page. She says, 'I love the photos in **Pure Enchantment**, and it brings back memories of a very happy day.' She used Adobe Photoshop to alter her photo, changing the image of her grandbaby to black and white while maintaining the coloured background. A photo of the field of bluebells was enlarged and printed on vellum to use as the page background. The green border around the page has mitred corners and lies on top of the background photo.

tip Layer a border on top of your background paper. You'll want to mitre the corners like Debbie did here for a clean, crisp look. Many cutting mats have guidelines to help you create a 90° angle at your corners.

tip Edge your vellum with chalk to add another layer of colour to your page. In **Dream** the chalk around the vellum window helps frame Jess's face. You can apply chalk with cotton swabs, but sponge tip applicators lay down more colour. When applying chalk to any edge, brush from the solid area outwards so you don't rip the vellum or paper.

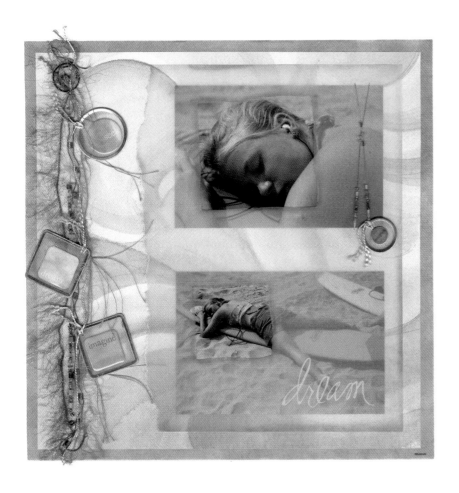

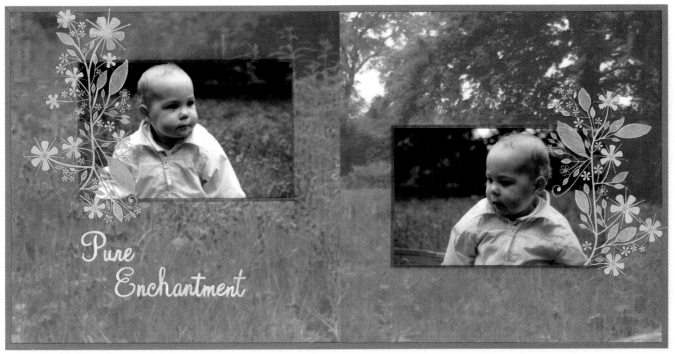

jubilee
cardstock: Bazzill Basics

This is the layout that started it all. (I was surprised when I realized this would be the final page in this section. Funny how things happen, isn't it?) I walked into ScrapMagic in 2002, saw these pages, and wanted to share what I'd seen with the world, a simple but striking layout made with few products. Debbie used cardstock,

a craft knife, and adhesive. She began by creating the Union Jack to fill the centre third of her page. Finally, Debbie carefully hand-cut the word 'Jubilee' so that she could use the negative space over a sheet of gold card and the positive letters on a gold background.

Sure, it's fun to use embellishments and accents, but you don't need to use them on every page

to create a dynamic layout. Focus on the reason behind your layout, your photos, and the theme you want to create, and then choose the appropriate products to make your page.

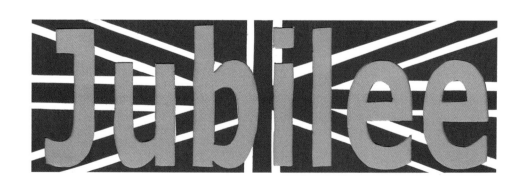

our honourable mentions

Studying other people's layouts can put you on the fast-track to design excellence. A look through Our Honourable Mentions will give you massive ideas for your own work. We've positioned these layouts without copy between them so you can make straightforward comparisons.

A few of these layouts rely on imaginative use of embellishments— **Chug-a-Bug**, **Read**, **Sunflowers**, and **Ethan Wheatley**. Others feature striking, yet simple, positioning of elements and the tilting of a photo— **Sandy Toes**, **Paddling Under His Own Steam**, and **Claire**. Note that **Silence is Golden**, **Pebbles**, and **Beach Bum** all have a dominant photo in the lower right quadrant of the page.

Yet by changing colours and embellishments, the pages all look different. **Revelation** and **Bath Time** both use photographic sequences to tell stories. **Kimono Boy** and **Beach Bum** repeat clothing patterns in the background paper. **Silence is Golden** and **Revelation** include ephemera in their designs both as embellishments and information sources.

TRACY CANHAM
Huntingdon, Cambridgeshire

NICOLA CLARKE
(Submitted by Artbase)
Basildon, Essex

LIZ DAVIDSON
Welwyn Garden City, Hertfordshire

BEVERLEY FLETCHER
Bourne End, Buckinghamshire

DAWN INSKIP
Shefford, Bedfordshire

CAROLE LYDALL
Birmingham, West Midlands

JENNIFER RIGG
Watford, Hertfordshire

VICKY SHIPMAN
Salisbury, Wiltshire

BRONAGH SHIRLOW
Coleraine, Northern Ireland

GILLIAN SMELLIE
Brancepeth, County Durham

KIRSTY WEBB
Norwich, Norfolk

ALISON WESTGATE
Beckenham, Kent

KARYN WHEATLEY
Coventry, West Midlands

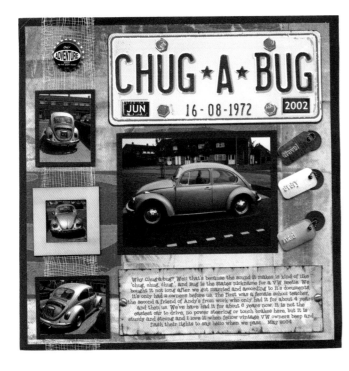

Chug-a-Bug
TRACY CANHAM

Tracy says, 'This layout was great fun to do.' She laughs as she tells new scrapbookers, 'Be prepared for scrapbooking to take over your life, your thoughts, and especially your wallet.'

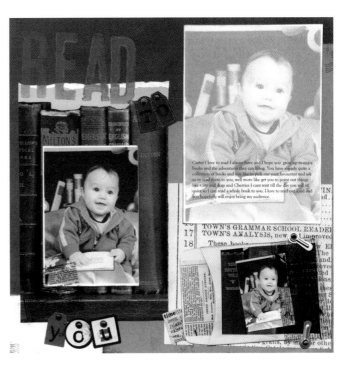

Read
NICOLA CLARKE (submitted by Artbase)

Nicola enjoys working 'with like-minded people in the most wonderful scrapbooking store, Artbase.' She has also met friends from all over the world through online scrapbooking.

kimono boy
BEVERLEY FLETCHER

Beverley says, 'Because I still view myself as new to scrapbooking, I try to use a new technique on each layout.' For this layout, she scanned her son Nathan's kimono to get the patterned paper.

silence is golden
DAWN INSKIP

Dawn likes to scrapbook 'the little things in life.' She doesn't scrapbook chronologically—instead she likes to create comparative pages through time.

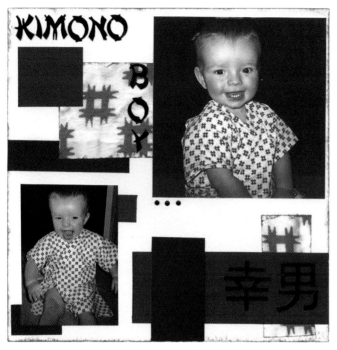

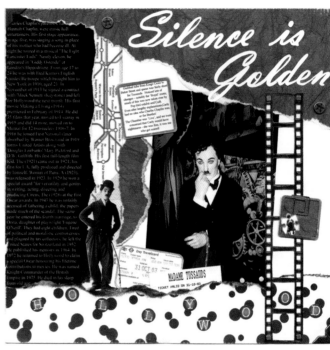

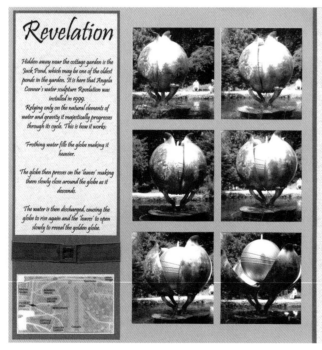

revelation
CAROLE LYDALL

Carole uses a digital camera. She appreciates being able to preview the shot right away and retake it if necessary. Plus, she can take as many shots as she wishes and just print the best ones.

pebbles
VICKY SHIPMAN

Vicky spent ten years as a rubber stamper and card maker before discovering scrapbooking in 2000. She tells new scrappers, 'Don't think that everything has to be perfect. Use your stash, don't just collect it.'

bath time
BRONAGH SHIRLOW

Bronagh suggests that scrappers take the time to learn a little about photography. 'A good photograph is half the battle,' she says.

sandy toes
GILLIAN SMELLIE

Gillian says, 'Don't start with your most special photos. Play around with ones that you don't mind cutting. Once you feel more confident you can move onto the special ones.'

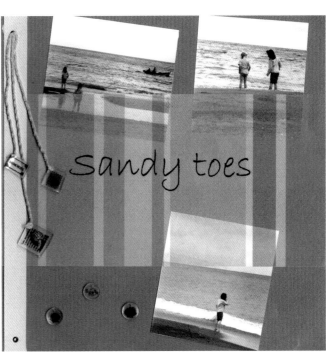

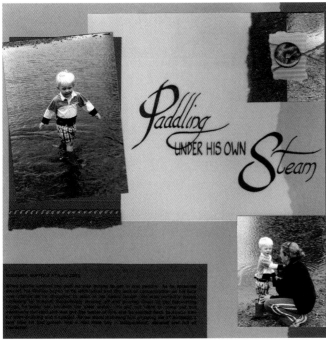

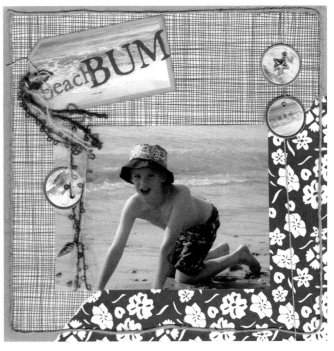

paddling under his own steam
KIRSTY WEBB

'My favourite layouts are not necessarily those which have taken the most time to complete or utilise complicated techniques but those which express something special to me,' says Kirsty.

beach bum
ALISON WESTGATE

Alison calls scrapbooking 'an obsession' and works at ScrapMagic in Surbiton to share her enthusiasm. She suggests getting copies of photos so you can rework layouts as your style evolves.

sunflowers
LIZ DAVIDSON

'There's no such thing as a bad page,' says Liz. 'It's what makes you feel good!' She scraps in chronological order because it forces her to get the less inspirational photos done.

ethan wheatley
KARYN WHEATLEY

'The friends you scrapbook with are the most important resource you'll have for both inspiration and advice,' explains Karyn. She gets together with her friends at local crops to share ideas and have a great time.

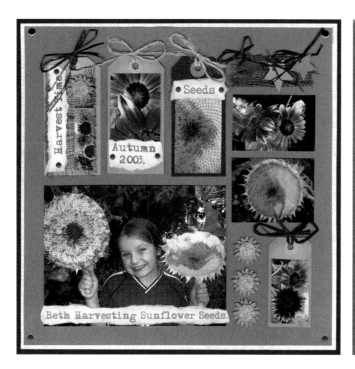

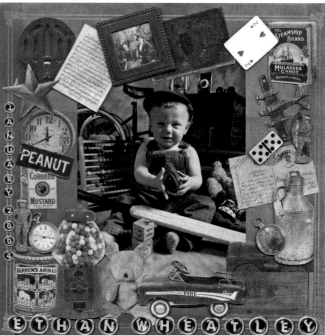

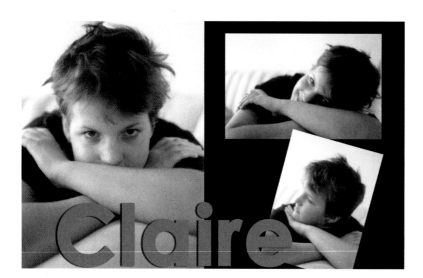

claire
JENNIFER RIGG

'Despite loving all sorts of stash, I am just much happier doing digital layouts (such as this one) on Adobe Photoshop 7. I don't know why, but I think my "real life" layouts lack inspiration!' says Jennifer.

How To Win Scrapbook Contests *by Shimelle Laine*

Editor's Note: Shimelle is a member of both the Creating Keepsakes Hall of Fame and the PaperKuts Power Team

Before entering a contest, check your philosophy. Are you entering to win? Or are you entering to challenge yourself? Or to share a piece of work that already makes you proud? Think of it this way: You decide to buy a lottery ticket. When the numbers are called, you don't win. Will you call in sick to work the next day, beside yourself in the tragedy? Of course not. In fact, sooner or later, you'll probably try again. That's the contest attitude. Develop it, or face the dangers of becoming emotionally controlled by a dozen factors that remain out of your control. Then do everything you can with what's in your control.

Follow the rules.
Read the fine print and follow it to the letter. Post your entry in plenty of time as to not worry needlessly that all your hard work could arrive too late. Include any information requested in the rules—you're certainly not going to win if you're disqualified for not listing a daytime phone number or your full name. Don't enter the same layout in more than one contest. Win both and you'll regret it.

Colour copy with a pro.
You've already double checked and triple checked the rules, so you know how many pages to submit and what size to make the required entry copies. Before shelling out for those full-colour reproductions, take the time to make sure everything on your page is securely positioned exactly where you want it. Describe your photocopy requirements clearly and make sure you get the colour as true as possible. Specialist copy stores often have large bed scanners that will eliminate many of your 12x12 headaches. Above all, work with your photocopy expert. The end result will be a copy that gives the judges an accurate representation. Clarity should always be your priority.

Treat your entry like a layout.
No matter how innovative your layouts, poor presentation makes a poor impression. Compile your entry on cardstock. Mat your colour copies and attach supply lists in a tidy, streamlined fashion. If your entry fills multiple pages, add a simple binding so there's no chance your pages could be accidentally separated. There's no need to decorate your entry (as it could take the focus away from those pages!) but consider adding a cover with the name of the contest and the requested personal details. Place your strongest layouts at the beginning and end of your entry to ensure the judges remember your work.

Mind the details.
Most contests require supply lists with each layout. And most judges can correctly identify the manufacturer of nearly every scrapbook supply in existence. Need I say how silly you could look if you rush your supply list and, as a result, get it wrong? And it gets worse: entering a product-specific contest means you need to feature that product. Make sure you have indeed used the correct product! There is nothing worse than mislabeling a product that was actually made by the competition. In addition to accuracy, make sure your supply list is complete and typed. Use this space to point out your innovative new technique or any detail that looks fabulous 'in real life.' Consider zoomed detail shots to show some small spectaculars, like subtle stitching. Finally, be sure to type your contact details. Sign your signature as your finishing touch.

Once you have done your best with your entry and posted it (in a sturdy envelope, of course) there is no point in waiting around in anticipation. Step away from the photocopies. Get back to your real life, your real family, even your real scrapping.

Shimelle's advice for submitting your work to a scrapbook publication is available at www.britishscrapbooking.com.

look back
patterned paper:
Making Memories
staples, rub-on lettering, metal
mesh: Making Memories
pink printed ribbon: Burnt Sugar
black dotted ribbon: Paperchase
sheer ribbon: Offray
lettering template: Scrap Pagerz
printed vellum: EK Success
spray paint: Plasti-Kote
photo by Fred Murphy

Shimelle used ordinary house spray paint for the lettering and the metallic bits. For 'look,' she cut the letters, adhered them with temporary adhesive, and painted over them, finally removing the letters to show the negative space. For the 's,' she sprayed straight through the lettering template. For the pewter flap on the book (lower right hand corner), she simply sprayed straight onto cardstock.

shimelle laine

CHAFFORD HUNDRED, ESSEX

Scrapbooking is a way I harness my inner historian by combining my growing collection of photographs with the countless journals filled with daily ramblings. SL

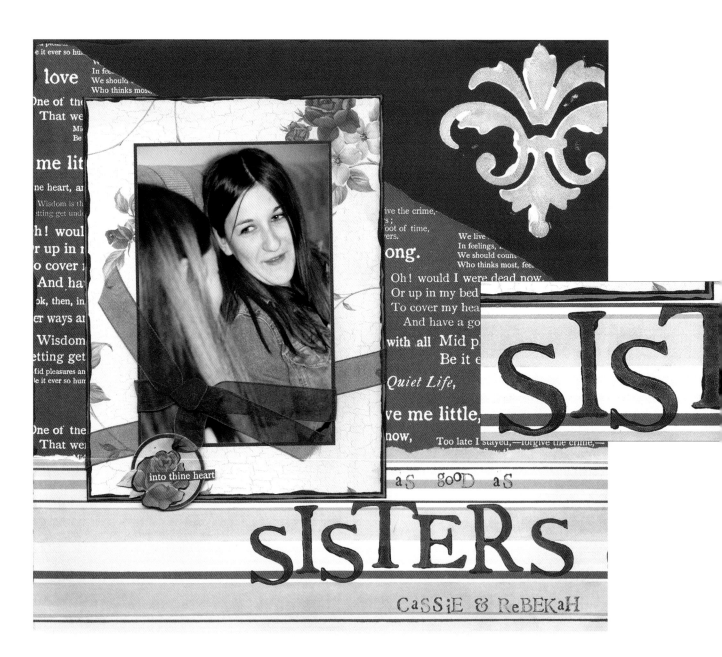

sisters *opposite page*
striped and floral paper:
Making Memories
text paper: 7gypsies
large letter stamps:
Making Memories
fleur-de-lis stamp:
Rubber Stampede
small letter stamps: PSX
sheer ribbon
tag
walnut ink
acrylic paint

Shimelle perfectly captures an affectionate moment between friends. Notice how she combines striped, floral, solid, and printed word paper patterns. The secret? The repetition of colours. Repetition is key in any successful page whether you repeat colours, shapes, themes, or images. The fleur-de-lis extending off the page takes our eyes with it, adding interest and motion.

On this small tag, Shimelle adds a simple message—*into thine heart*—which echoes the theme of the page. The tag has been aged with walnut ink.

Try stamping your page title in acrylic paint like Shimelle did. The paint is opaque and easy to use. Practice on an unused piece of paper first so you can check your results.

Shim's very personal journaling conveys a universal feeling, the need to get perspective on our lives. Under the journaling vellum is another photo of the lake scene, and under vellum in the upper right are ducks paddling serenely. The off-centre tilt of the main photo adds interest and visual appeal.

tip Don't be afraid to journal about your quiet moments, your moments of reflection. These are important and integral parts of who you are.

tip Wrap a string or piece of ribbon around the bottom of a photo when you tilt it. The fibre helps make an off-kilter image feel grounded.

tip Anchor your embellishments by overlapping them. This keeps them from looking disorganised.

tip Shimelle suggests that you draft your journaling before planning the other page elements. She says, 'Do it with your photos in hand. Journaling first will not only guarantee you never sacrifice your story, it can also give you the direction you need to choose appropriate accents to extend that story. Your result? A cohesive layout in which photos, journaling, and accents work together.'

a moment stolen *below, right*
dictionary paper: 7gypsies
script paper: K&Company
staples: Making Memories
safety pins: Making Memories
rhinestones: embelleez
film negative: Rusty Pickle
printed twill: 7gypsies
printed ribbon: Burnt Sugar
butterfly stickers: The Gifted Line
ribbons
brads
denim
silk flowers
page from vintage dictionary
acrylic paints
metallic ribbon

'I followed that couple for blocks to get the photos I wanted,' explains Shimelle. Well, maybe the rest of us aren't so determined, but you must admit Shimelle has perfectly captured the nature of stolen moments. As you can see, she loves using paper patterned with words, in this case in three variations. Shim enjoys using unexpected embellishments. Even scraps from old jeans make their way onto Shimelle's pages.

Inking the edges of page elements makes for a more finished look. In this case, the gold Shimelle used also helps tie the accents together and to delineate each embellishment.

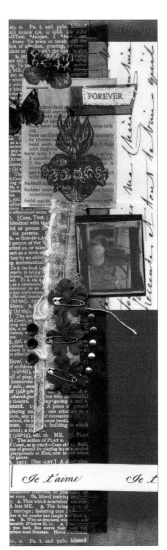

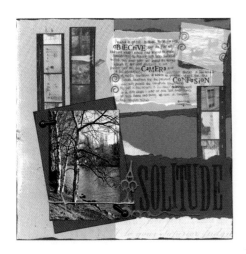

solitude
large letter stamps: Making Memories
small letter stamps: PSX
clips: Making Memories
clock hands: Just Charming
photo holders: 7gypsies
blue patterned paper: Rusty Pickle
script paper: K&Company

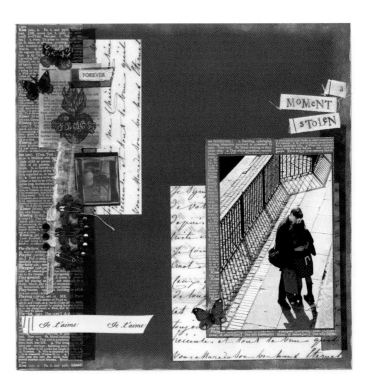

joanna campbell slan

SUNNINGDALE, BERKSHIRE

When I complete a scrapbook page, I feel such a sense of accomplishment. Once it's done, I have documented a memory—and that sense of overcoming the transitory nature of our lives makes me feel great. JCS

they stoop to conker
mesh
brads: Unique Notions
vellum: Paper Adventures
cardstock: Paper Adventures
alphabet stamps:
Stamp Craft and Hero Arts
watercolour pencils: Derwent
pen: Sakura
watercolours: Prang

The whole idea of the game of conkers—played with the nut from a horse chestnut tree—tickled me. I created my watercolour images of the leaf and nut, colour copied them and used them twice— as the focal point on top of the mesh and as part of the tag. My journaling is on the reverse side of this tag.

I also colour copied pages from old books and stained them with walnut ink and tea for use as background paper.

To age your book pages (or any papers), soak them in tea (brew four cups of strong tea to make a bath) or spray them with walnut ink. Make extra pages for later use.

The word 'conker' is stamped and then coloured with pens on paper clay. To use paper clay, flatten it, cut it to the desired shape with a craft knife, let it dry, and treat it like what it is—a big thick piece of paper.

tip Paper clay can grow mould. I keep mine in an airtight jar in my refrigerator to help prevent this.

tip Customize your cardstock by drawing lines of watercolour pencil in your page colours and smearing them with a damp cotton swab.

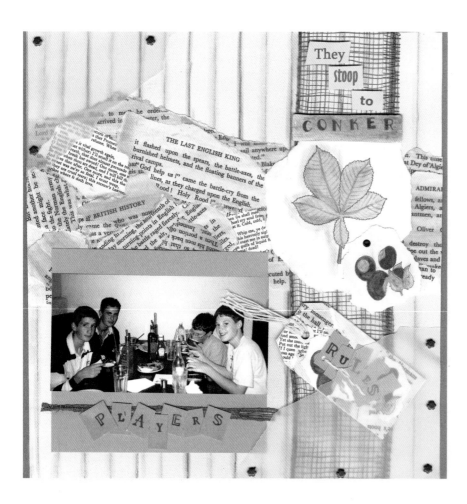

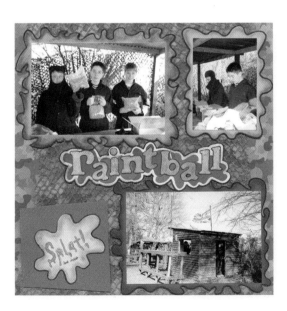

order of the garter
paper: Paper Adventures
tissue paper:
Buckingham Palace gift shop
metal rimmed tag:
Making Memories
metallic mesh: Glitterati
vellum: Paper Adventures
photo corners
foam dots
letter stamps: Hero Arts

The splendour of this ceremony was truly a high point of my family's year in England. Supposedly, one of my ancestors actually was a Knight of the Garter, so I wanted to include information about the honour itself. I did that in the torn pieces of paper on my tags. I also used images of the garter emblem to further explore the topic. Note the layers of tissue paper printed with gold crowns glued over the patterned paper.

tip You can change the colour of plain white photo corners by rubbing them across an ink pad as I did here.

tip Taking photos at ceremonies is tricky; no one stands still and tall people pop up at the most inconvenient times, so you have to work with what you get. Images from the Internet or books can help round out your page design. Do be mindful of honouring copyrights.

tip Play with your stuff. That's right. Nothing is sacred. Colour it, scratch it, rip it, smear it, and use it. There are no rules for scrapbooking, no scrapbook police who'll come to your house and arrest you. Get the maximum use out of all your supplies by asking yourself, 'What can I do with this? How can I make this work? How can I alter this to suit my needs?'

paintball
cardstock: Paper Adventures
camouflage paper
chalks: Craf-T Products
letter template:
Frances Meyer, Inc.
acrylic paint: Delta
pens: Sakura
tape: 3M

The flap serves a double purpose. My journaling is on the inside and it covers a business card that wouldn't match visually.

It may not look like it to you or me, but this was heaven for my son and his mates. My goal was to reproduce the grubby, paramilitary look of the paintball world. A green mesh bag that once held oranges is stretched across the page; its edges are taped down on the wrong side. The photo mats mimic the operative action of paintball, splattering your opponents.

beverley stephenson

WHITLEY BAY, TYNE AND WEAR

Juggling a career, a family, and a website, Bev makes time to scrap by staying up late or—with the blessing of her very understanding husband—by attending crops across the UK.

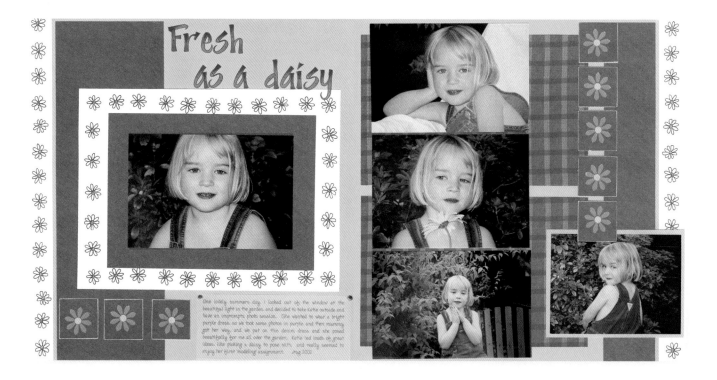

fresh as a daisy
patterned paper: My Mind's Eye
cardstock
vellum
brads
flower punch
hole punch
letter stickers: Susie Ratto
layout from a sketch by
Shimelle Laine

Bev's eldest daughter Katie is lovely to photograph. 'She really enjoys posing for the camera, and we always have loads of fun and laugh a lot when we have a photo shoot,' says Bev. Good photos like these should be the focal point of a layout, and here they are just that.

tip The rows of daisies function like stripes. Your eyes see a visual line. Bev used the daisies to direct us to her pictures and to frame them.

tip A thin mat adds colour and keeps the daisy from blending into the blue background. Thin mats are a great tool. Experiment with them.

love you

denim paper: My Mind's Eye
vellum: Over the Moon
flowers: EK Success
alphabet template (page title):
Coluzzle
eyelets

By using a monotone palette and cropping tightly, Bev focuses on her daughter's face. The reverse lettering cut out of the script-patterned vellum is simple and perfect for this layout. Repeating the tiny flowers in the negative space of the letter 'O' pulls together all the embellishments. Notice the flower-shaped white brads in each corner.

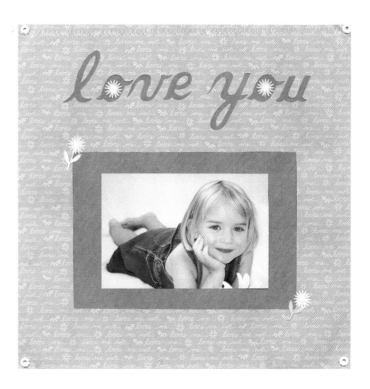

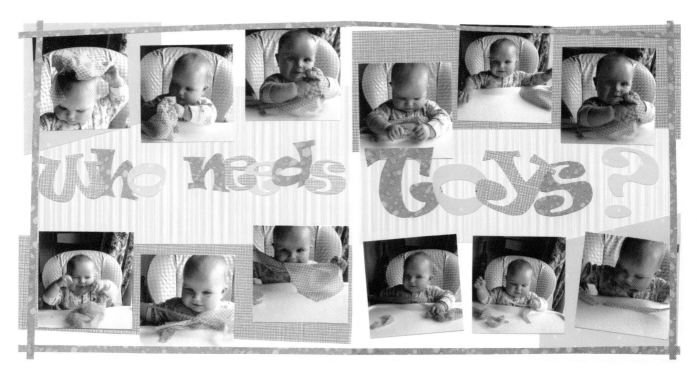

who needs toys?
watercolour paper:
Making Memories
cardstock
font (Ravie)

And who needs tons of embellishments? This colourful page picks up on the blue cleaning cloth and repeats the colour to pull the entire spread together. Bev says

this is her favourite layout because the photos show how much her youngest daughter Molly enjoyed playing with the cloth. She adds, 'These are the kind of photos I would never have taken before I started scrapbooking.' But can you imagine the fond memories this layout will evoke in years to come?

tip To scraplift this layout, choose a palette, divide your page into thirds and run the page title across the middle third. Border the page with coloured strips or ribbons and space photos along the top and bottom.

tip Bev says, 'Don't be afraid to ask your scrapbook friends for

suggestions. It's a brilliant way to learn and improve your pages at the same time.'

tip Match your type style to the mood of your pages. Use a playful typeface on a fun page and a more classic type style on a serious page.

mary anne walters

RAMSDELL, HAMPSHIRE

No one can tell your family's stories like you can. Do it now—get started before the memories you have get crowded out by a whole new set of memories, the ones you are making every day. MAW

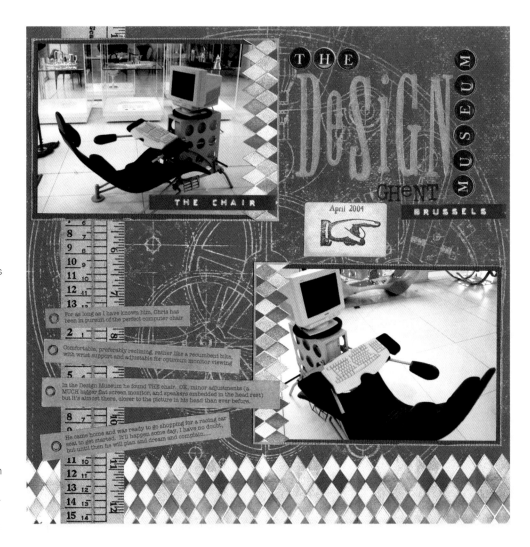

the design museum
cardstock: Creative Imaginations
patterned paper: Sticker Studio,
Karen Foster
metal hardware textured stickers:
Sticker Studio
accents: Nostalgiques
label tape: Dymo
rub-on lettering: Making Memories
foil leafing pen: Krylon
date stamp: Making Memories
foam stamps: Making Memories
copper pigment ink: ColorBox

Here Mary Anne journals about her husband's quest for the perfect chair. Who would ever guess that a page about a chair could look so interesting? The textures make it so. The bottom border of harlequin diamonds repeats on the edges of the photos. Rub-on lettering on faux vintage typewriter keys works with a rubber-stamped title and Dymo tape to create a striking page title.

tip Use a vertical embellishment (like this ruler) as an anchor for your journaling.

tip Mary Anne says, 'Be experimental! Look everywhere for inspiration. I like the hardware store. Washers, little hinges and closures, wire mesh screening can all be added to your pages. Raid your craft cabinet! The embroidery floss from your cross stitching, acrylic paint, clay, stamping ink are all ways to make your scrapbook pages unique.'

wishing well *opposite page, top*
cardstock: Paper Loft
patterned paper: Penny Black,
Rebecca Sower Designs
Maurayuma paper: Magenta
tag: EK Success
conchos: Scrapworks
lower case alphabet stamps:
Hero Arts
buttons
ribbon
air brush pens: Blo-Pens

ink: Archival Ink
spatter netting
mesh

Instead of posing Jack next to the well, Mary Anne caught her son in action. The entire page supports the theme of making a wish. The circle conchos on the tag echo the shape of the round coin and button embellishments. Inside the conchos, the letters spell *WISH*.

The coin embellishment overlaps the photo, which is overlapped by the page title, which is overlapped by the tag. Overlapping elements ties them together so they aren't scattered across your pages.

tip The mat beneath the coin is wrapped with silver wire. That small touch helps the embellishment stand out on the page.

Create your own embellishment. Start with a circular object: a button, a token, a disk, or a circular image like a picture of a wheel. Mount the circular object on a square mat and wrap wire or thread around the top edge.

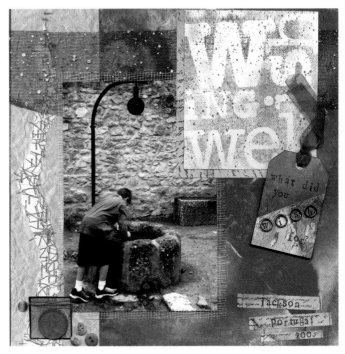

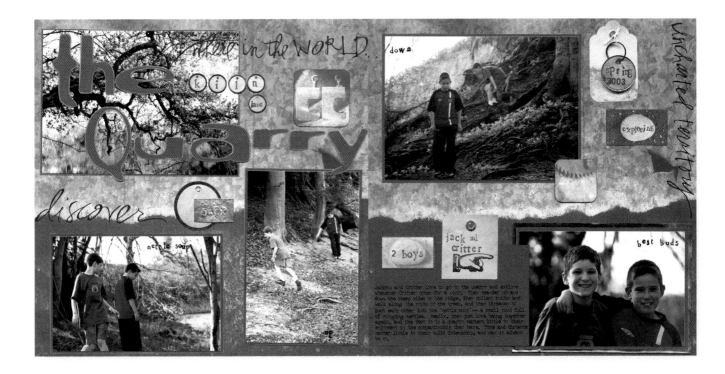

the quarry
cardstock: Creative Imaginations
patterned paper: Sticker Studio and Karen Foster Designs
stickers (metal hardware images): Sticker Studio
thin wire
accents: Nostalgiques
label tape: Dymo
rub-on words: Making Memories
foil leafing pen: Krylon
date stamp: Making Memories

foam stamps: Making Memories
ink: ColorBox

Mary Anne has a special fondness for **The Quarry** because it is so OTT (Over The Top). Her journaling chronicles what Jack and his friend Critter love to do—meander up and down the steep sides of the ridge, threaten each other with stinging nettles, and generally just have fun.

Mary Anne's pictures capture the boys' activities with simple stamped captions: nettle soup, up, and down.

The name JACK was stamped onto onto a piece of scrap metal with the sort of equipment police use to mark property. Almost anything that can create lettering is fun to use on scrapbook pages—labeling systems, rubber

stamps, letter stencils, die-cut systems, and so on.

tip Use your accents to make visual statements. Here a hand points to Jack and Critter, both directing the eyes and labeling the boys.

page gallery

These pages are full of great ideas for layout design. Scraplift them or use them as starting points for your own work. After all, the essence of creativity is putting an individual spin on what already exists. Remember: There is no right or wrong when you scrapbook. Take a look to the right (opposite page) and you'll see three judges' renditions of Abby. Each judge was given the same paper and photograph, and still you see vastly different layouts. Every layout should be a reflection of you, because you are a one-off!

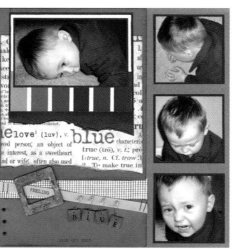

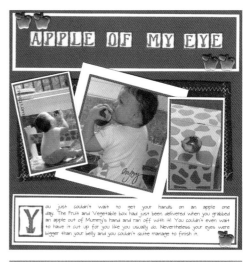

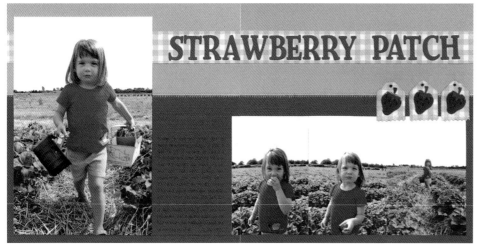

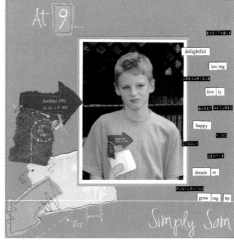

hampton court
VICKY SHIPMAN

feeling blue
BRONAGH SHIRLOW

apple of my eye
KARYN WHEATLEY

strawberry patch (two page spread)
VENESSA MATTHEWS

simply sam
ALISON WESTGATE

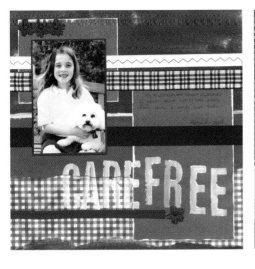

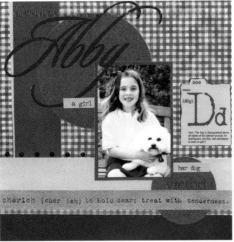

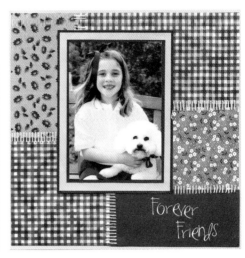

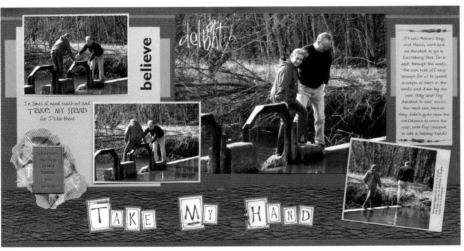

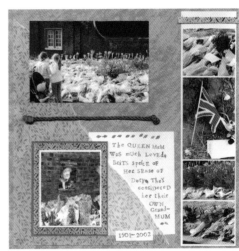

abby
SHIMELLE LAINE

abby
MARY ANNE WALTERS

abby
BEVERLEY STEPHENSON

sphere
SARAH WHEATLEY

within you
BRONAGH SHIRLOW

wisteria
CAROLE LYDALL

take my hand (two page spread)
ANNE PARRY

queen mum
JOANNA CAMPBELL SLAN

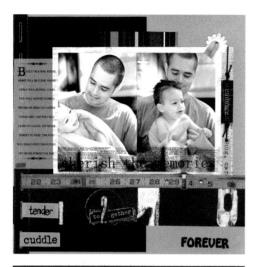

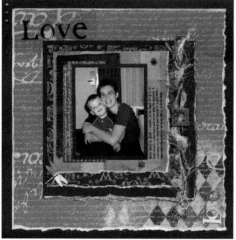

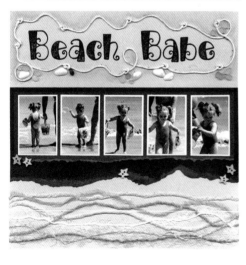

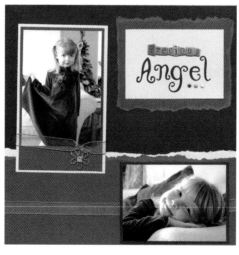

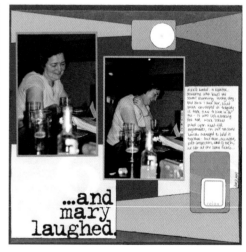

embrace
NICOLA CLARKE

view from the top (two page spread)
ANNE PARRY

love
ALISON DOCHERTY

fun girl
ALISON ROWE

my snowflake
VENESSA MATTHEWS

beach babe
ANNE PARRY

precious angel
SAM EVERETT

and mary laughed
SHIMELLE LAINE

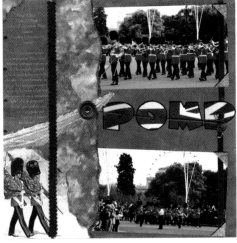

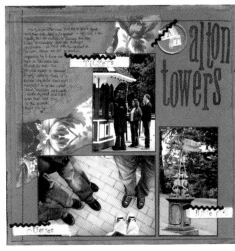

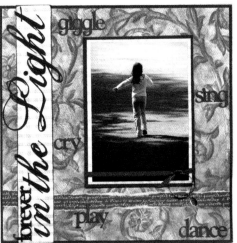

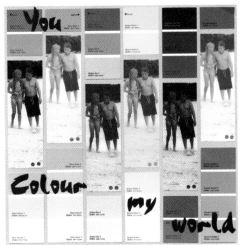

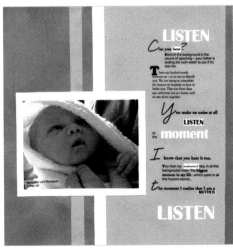

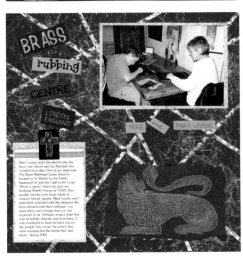

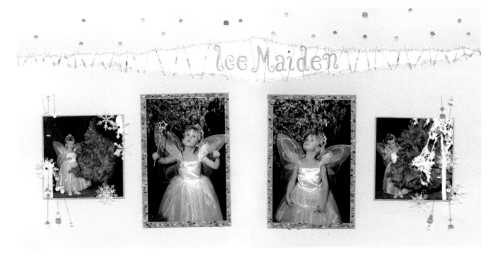

struie
GILLIAN SMELLIE

forever in the light
MARY ANNE WALTERS

brass rubbing centre
JOANNA CAMPBELL SLAN

pomp
DAWN INSKIP

you colour my world
MANDY ANDERSON

ice maiden (two page spread)
DEBBIE WOOD

alton towers
SHIMELLE LAINE

listen
MICHELLE THOMPSON

the best of the best cards

From the many cards submitted to our The Best of the Best Card Contest, we selected three winners and four designs. Nothing says 'heartfelt' quite like a handmade card. Each mini-design can be created to reflect not only our exact sentiments but also the individuality of the recipient.

relax
ZOE MARTIN

cardstock: Bazzill Basics
patterned paper: Doodlebug Designs
dictionary definition: Making Memories
ink: ColorBox
pen
beads

Zoe created the beadling, a butterfly embellishment made of wire and beads. The edges of her card background have been lightly streaked with ink so as to better match the patterned paper.

with thanks
NATALIA HARANDON

cardstock
patterned paper: Making Memories
fluid chalk ink: ColorBox
foam stamp set: Making Memories
acetate
foam tape
button: Doodlebug
beads: Guttermann, Embelleez
font (Think Small):
Two Peas in a Bucket

This shaker box was made with foam tape and acetate, but you could use a transparency instead. The little butterfly is actually a button.

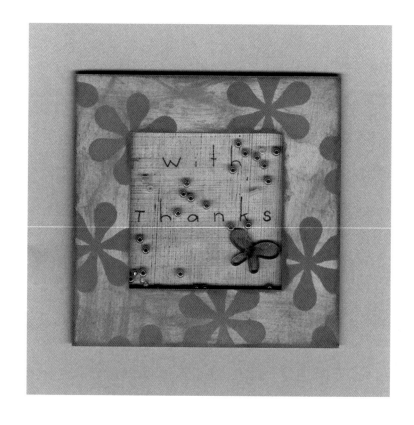

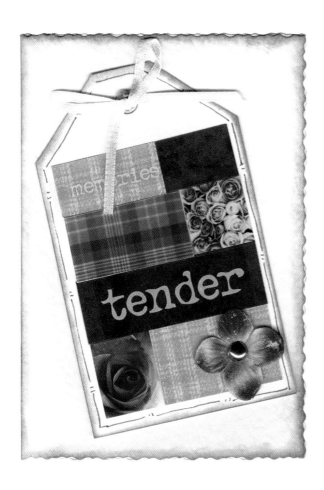

tender
LIZ DAVIDSON

chalk
pen: Zig
paper: KMA
cardstock: Bazzill Basics
brad
silk flower
word sticker: Bo Bunny Press
ribbon

Liz cut a tag and chalked the edges adding Zig marker lines for definition. On a photography site that allowed downloads, she found a photo of the flowers and printed it onto photographic paper. The edges of the card were chalked to repeat the colouring on the tag.

all occasion card
LIZ DAVIDSON

cardstock: Paper Mill
organza ribbon
paint sample strips
glitter glue
pen: Zig
punches: Woodware Craft Collection, Carl, Personal Impressions

Liz used paint sample strips for her small squares and embellishments, punching out hearts, flowers, and stars and adhering them. She used a glitter glue called 'Champagne' to dot the corner of each square and to create centres for the flowers.

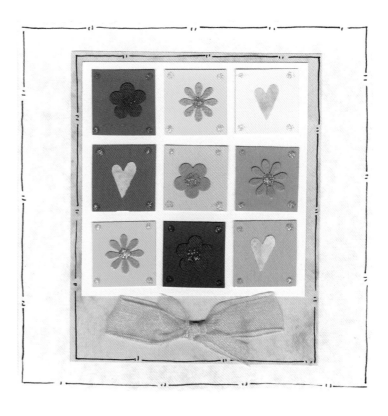

cards

If you are a scrapbooker, recognize that cards offer a wonderful mini-workshop for testing new ideas and techniques. If you are a cardmaker, realize that a scrapbook layout is simply a bigger card with photos! It's fun to move back and forth from one craft to another.

baby love
SAM EVERETT

cardstock: Bazzill Basics
foam stamps, acrylic paint, ribbon and brad:
Making Memories
metallic rub-ons: Craf-T Products
flower: JKK Designs

Metallic rub-ons colour the edges of this card with a shimmering purple glow. The product looks like a coloured wax and is rubbed on with your fingertip or a sponge applicator. A simple, single brad highlights the centre of the silk flower.

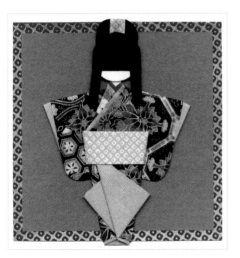

japanese paper lady ◀
ALISON ROWE

Origami and washi papers: Be Crafty
cardstock: Craftwork Cards

Ali has studied and practiced Origami, the traditional Japanese art of paper folding, for years. This paper doll is her favourite design.

go fish ▶
JOANNA CAMPBELL SLAN

cardstock: Paper Adventures
suede and metallic paper: Paper Adventures
mulberry paper: Paper Adventures
accent (fish) Marcel Schurman Creations
glitter: The Art Institute
packing tape: 3M
punch
jewel

This took me all of fifteen minutes to assemble, cutting the negative space square with my Sizzix Personal Die-Cutting System. The packing tape is pressed onto the backside of the frame with the sticky side up to capture the glitter.

daisy ▲
DEBBIE WOOD

cardstock: Bazzill Basics
pens: Zig

Debbie used the torn paper technique to create the daisy petals, the yellow centre, and the leaf. One way to get optimum control over your paper as you tear is to use a waterbrush like the one made by Yasautomo. Just outline the shape you want with the waterbrush, wait a second, and tear.

8th birthday ▶
MANDY ANDERSON

stamps: Wordsworth
mulberry paper
heart clip, wire, vellum tag, heart shape,
brad: Making Memories
beads
token (birthday accent): Doodlebug Designs
chalks

Yes, Mandy used the same Doodlebug
Designs accent on this card as Alison did
on her birthday card on this same page.
But the cards look very different! Proof
again that each of us brings her own
creative vision to our projects.

birthday girl ▶
SAM EVERETT

paper, foam stamps, acrylic paint, buttons,
flower, brad, staples, scrapbook stitches
(thread): Making Memories
netting: Wiggly Woods

Sam lightly sanded the patterned paper on
this card, allowing a touch of white to show
through. Sanding like this can soften bright
colours. Note how she attached the netting
(mesh) with staples for added texture. For
both cards (this one and Baby Love),
Sam used foam stamps with acrylic paint.
Because the paint is opaque, and the
stamps are bold, her words are easy to see.

happy birthday ▼
GISELLE HOMER

paper: Paper Pizazz
brads: Bazzill Basics
eyelets, tag: Making Memories
sticker: Poemstone by Sonnets
lettering: hand drawn by Giselle

Not confident about your handwriting?
You can duplicate the look of this card by
writing your words and phrases on your
paper first, and then tearing and saving
those handwritten bits that meet your
approval. Confident about your handwriting?
Tear pieces of paper, adhere them to cover
the face of your card and then write your
phrases and words.

birthday ◀
ALISON PENSTONE

cardstock: Bazzill Basics
patterned Paper: KI Memories
token (birthday accent): Doodlebug Designs
ribbons: HobbyCraft, Wiggly Woods

Alison adds extra interest to a beautiful card
by threading different ribbons through five
holes. This technique would also look
interesting in a scrapbook page layout with
holes punched on just one side (like this
card) or holes punched all around the page.

reminisce ◀
MARY ANNE WALTERS

rectangular tag
embellishment: Making Memories
stamps: Hero Arts

Mary Anne saves her scrapbook page scraps to use for cardmaking. The next time you realize you over-bought your embellishments, don't despair. Bits and bobs are perfect for the odd greeting card.

thanks ▼
ALISON PENSTONE

cardstock: Bazzill Basics
patterned paper: Chatterbox
buttons: Junkitz
floss: DMC
label holder: Making Memories
fibres
ink: Ancient Page by Clearsnap, Inc.
stamps: PSX

To centre your stamping inside the label holder as Alison did, first position the label holder on your card. Second, lightly trace the empty (negative) space with a pencil. Find the middle and make a small dot. Now stamp your lettering starting from the centre of your word or phrase out from that centre dot. Finally, after the ink dries, erase your penciled guidelines.

christmas ▲
BEVERLEY STEPHENSON

paper: Paper Adventures
felt stickers: unknown
twill: Wiggly Woods

Notice that Beverley also makes good use of paper scraps. Bev customized her twill by running it through her printer to add the words 'Merry Christmas.' Although the felt sticker manufacturer is unknown, it wouldn't be hard to make similar embellishments for your cards or scrapbook.

happiness ◀
GISELLE HOMER

cardstock: Bazzill Basics
paper: Chatterbox
spiral clip and page pebble:
Making Memories
tag image: Life's Journey Stamp Collage
Embossed Paper by K&Company
word accent (happiness): Paper Pizazz

Giselle cut her collage tag from a 12" x 12" sheet of 42 stamp collage images. Each image is printed inside a cream-coloured border of embossed dots.

leaf ▶
ALISON DOCHERTY

patterned paper: 7gypsies, Pebbles Inc.
and unknown
handmade paper
cork paper: Magic Scraps
copper leafing pen: Krylon
brads
sticker (leaf): Stampendous

Alison shows a rare ability to combine
textures and diverse printed papers. Note
that all her work includes a strong focal
point image. The copper leaf inside the
frame is a negative-space sticker (the
sticker is just an outline) which shows the
handmade paper to great advantage.

nan ▼
SARAH WHEATLEY

cardstock: Bazzill Basics
patterned paper: PSX, Two Busy Moms
gold crumpled paper
mica
micro glass beads
walnut crystals
eyelets: Making Memories
frame: KI Memories
rub-ons: Royal & Langnickel
Diamond Glaze

Sarah antiqued the patterned paper with
walnut crystals. Both flowers were coated
with Diamond Glaze and then clear micro
beads were added to the centre of the focal
point flower. A piece of mica overlaps torn
and crumpled gold paper.

forget-me-not ◀
GISELLE HOMER

cardstock: Artoz
paper: Paper Pizazz, Paper Adventures
tag: Life's Journey Stamp Collage
Embossed Paper by K&Company
dried flower: Croft Petals
fibre: Scrapworks
eyelets: Making Memories

A piece of patterned paper with torn and
chalked edges was folded to create a
pocket which is secured with two eyelets.
Inside the pocket, a tag sits at an angle.
The tag was created from a single
stamp collage image matted with solid
purple paper.

birthday girl ◀
MARY ANNE WALTERS

stamps: PSX
ribbon
gingham patterned and solid papers
safety pin

Reverse image letters spell 'birthday girl.'
After stamping her letters, Mary Anne
punched them out with a circle punch.
Note the cute embellishment she made by
threading heart shapes onto a safety pin
and adding a bow.

baby boy ◀
MANDY ANDERSON

cardstock: Bazzill Basics
fibres, safety pin, brad:
Making Memories
eyelets, beads: Alphabeads
acrylic paint
font (Linsec)

Mandy used both positive (the word 'baby')
and negative (the word 'boy') lettering on
this card. The stencils that form the word
'BOY' were crumpled, flattened and
brushed with ink to get the right colour.
Pay particular attention to the fibre with a
safety pin and bead.

baby boy ▶
VENESSA MATTHEWS

cardstock: Bazzill Basics
rub-on words: Making Memories
embroidery floss: DMC
buttons

Venessa used zigzag stitches to fashion this colour blocked card which is accented with white thread, white buttons and white rub-on words. You could copy this card with any three harmonious colours in the same pattern, or you could enlarge this scheme for a colour-blocked scrapbook page.

happy birthday ▼
VENESSA MATTHEWS

cardstock: Bazzill Basics
patterned paper: Keeping Memories Alive
rub-ons, brads, ribbon: Making Memories
shrink plastic: Funstamps
flowers: Michaels

Venessa cut a piece of shrink plastic and rubbed on letters to spell 'Happy Birthday.' Then she punched a hole for the ribbon. She heated the shrink plastic to the desired shape and cooled it before adding the ribbon. The yellow cardstock is machine stitched in white thread.

happy easter ◀
CARRIE HOWARD

cardstock: Bazzill Basics
striped paper: Doodlebug Designs
embellishment (rabbit): Paper Bliss
paints and letter stamps: Making Memories
word sticker: BoBunny Press
acrylic paint

Nine tiles of coloured card and striped paper make this bunny outstanding. You can make any embellishment more important by matting it, but why not try a mat of tiles as Carrie did? Then she combined a word sticker (happy) with stamped letters to create her message.

stars ▶
ALISON ROWE

cardstock: Bazzill Basics
rubber stamp: Make Your Mark
pigment inks
Pop Dots: All Night Media

These stars are reverse images; that is, the star shape is a negative space and you ink the outside square around the star. First Alison stamped her stars in several colours, and then she punched them out with a small square punch and mounted them on Pop Dots.

thank you ▶
ANNE PARRY

cardstock
mulberry paper
gems
font (Donny's Hand)

Look back at Anne's scrapbook page **Flowers at Barnet Hill** on page 23. Anne zooms in on a single blossom for visual impact. This elegantly simple card design would be a great way to use any extra flower photos you might have left over from your scrapbook layouts.

happy birthday ◀
SARAH WHEATLEY

cardstock: Bazzill Basics
patterned paper: Paperfever
wire words and brads: Making Memories
beads: Embelleez
Diamond Glaze

Although they look like pre-made
embellishments, Sarah's small square
accents are really punched squares of
patterned paper thickened with Diamond
Glaze. The wire words 'happy' and
'birthday' are mounted on solid colour tags
for emphasis. Note the simple but stunning
border of beads strung on a wire.

strawberries ▶
DEBBIE WOOD

cardstock: Bazzill Basics
die cut: QuicKutz

Four colours of cardstock are used in four
different combinations. Notice how Debbie
alternated the background colours of the
squares and their strawberries diagonally.
So you have a pink berry on turquoise
upper right and a turquoise berry on pink
lower left, and then a yellow berry on lime
green upper left and a lime berry on yellow
lower right.

thank you ▲
ALISON ROWE

cardstock: Bazzill Basics
patterned paper: Creative Imaginations
rubber stamp (thank you): Penny Black
pigment ink
embossing powder
Pop Dots: All Night Media

After stamping the phrase 'thank you,'
Alison embossed the words and cut them
apart into individual letters which she then
mounted on Pop Dots. (If you don't have
small enough Pop Dots, cut the Pop Dot
backing between the dots into the size
you need.)

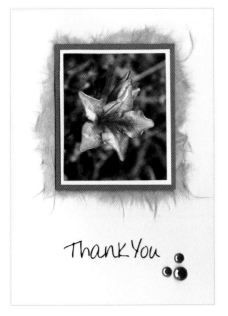

birthday ▶
ALISON DOCHERTY

cardstock: Bazzill Basics
patterned paper: KI Memories
brads: Making Memories
letter brads: Colorbok

The overlapping analogous colours form the
background for the word 'birthday' spelled
out in letter brads. Pay particular attention to
the pleasing proportions of coloured
cardstock Alison used: 3/3 (turquoise), 2/3
(moss green) and 1/3 (navy).

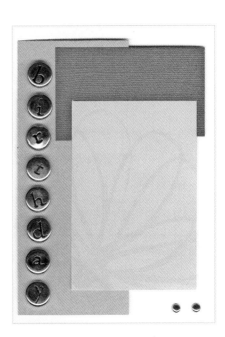

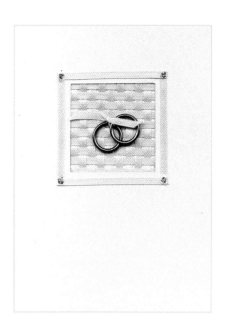

wedding card ◄
ALI ROWE

Ali wove the ivory ribbon to create the backdrop for the rings, which are actually brass curtain rings! More ribbon runs around the outside edge of the window to create a frame. The pearlescent cardstock is striking and makes the perfect backdrop for her faux wedding rings.

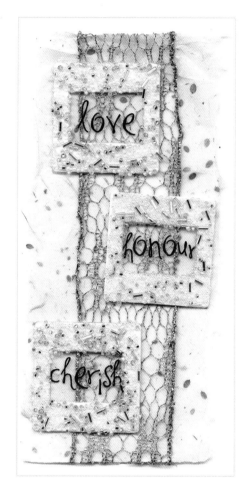

love, honour, cherish ▶
MANDY ANDERSON

mulberry paper
wired ribbon
transparency
rub-on words:
Making Memories
beads
slide mounts

The combination of textures makes this card a dramatic one. First, Mandy applied her rub-on wording to her transparency.

Then she cut out the transparency rectangles making them slightly larger than the openings in the slide mounts. Finally, she glued beads to the slide mounts and assembled her card.

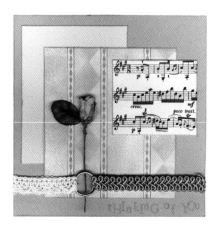

thinking of you ◄
ALISON PENSTONE

cardstock: Bazzill
patterned paper: Creative Imaginations
patterned paper (music): unknown
ink: Tim Holtz Distress Ink
binding, lace, ring and rose: Wiggly Woods
stamps: PSX

An eclectic mix of accents works well to make this stunning collage. Notice how the stripes on the patterned paper emphasize the vertical line formed by the rose. The braids on the bottom bring attention to the card title. Alison edged her papers with gold ink to further tie the mix together.

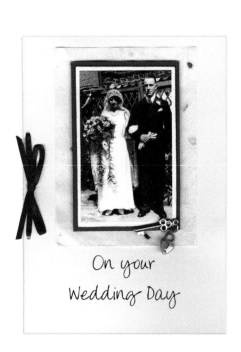

primarily you ▶
MICHELLE THOMPSON

cardstock
letter stickers: Doodlebug Design,
Making Memories

In the style of Piet Mondrian neoplasticism,
Michelle hand cut the black frame using a
craft knife. Then she filled some of the
blocks with primary colours. Neoplasticism
is the belief that art should not be the
reproduction of real objects, but the
expression of the absolutes of life which
meant working with vertical and horizontal
lines at right angles, noncolours (black, gray,
and white), and primary colours.

i love you ▼
SARAH WHEATLEY

cardstock: Bazzill Basics
mulberry paper
Friendly Plastic
glitter: Crystal Stickles
Pop Dots: All Night Media
Font (Chopin Script)

Sarah cut Friendly Plastic into squares and
heated them to form a mat. Then she cut
the Friendly Plastic mat into a heart shape.
Finally, she re-heated the heart to shape the
rounded edges. When working with Friendly
Plastic, cut it larger than your final shape.
You can heat the plastic on a lightly oiled
piece of aluminium foil using a heat gun or
in hot water.

jingle ◀
CARRIE HOWARD

cardstock: Bazzill Basics
silver metallic paper
printed twill, rub-on words:
Making Memories
bottle caps: Li'l Davis Designs
sleigh, bag, gifts accent: Paper Bliss

Sure the embellishments are pre-made, but
the way they are combined is both classic
and original. Copy this layout for your cards
or create a large embellishment for your
scrapbook page. If you choose an accent
with another theme, you might consider
replacing the bottle cap. How about a
pressed flower, a concho or label holder
with a word inside, or a faux wax seal?

wedding day ◀
ANNE PARRY

cardstock
mulberry paper and ribbon: HobbyCraft
key and lock charms
font (Donny's Hand)

While Anne used an old wedding photo as
the focal point of this card, you could
reproduce any romantic photo in black and
white and do the same. Another idea to
copy: Attach charms to one corner of a
photo with a jump ring.

thank you ◀
VENESSA MATTHEWS

cardstock: Bazzill Basics
button
flower: JKK Designs
rub-on letters: Making Memories
ribbon

By placing her words directly above the
ribbon, Venessa directs our eyes along a
horizontal line in the lower 1/3 of the card.
A button or a brad makes a great pistil for a
silk flower.

Thank You

Thank you to Lesley, Peter, James and Patrick Hindmarsh for their assistance and hospitality.

We appreciate the support of our many prize sponsors: Paper Adventures (www.PaperAdventures.com), Bramwell Yarns & Crafts (www.bramwellcrafts.co.uk), PM designs (www.designsbypm.com), Cut-It-Up (www.cut-it-up.com), Unique Notions (www.my-memories.net), and EFG (www.newsletterinfo.com). Thanks to 7gypsies for material assistance.

Thanks to Shimelle Laine and Julia Kressig for all sorts of stuff including proofreading.

Special thanks to The BOBs judges: Shimelle Laine, Beverley Stephenson, and especially Mary Anne Walters. We also wish to thank Debbie Woods of ScrapMagic; Jane Verlander; Caroline Meisel; and Carol, Robert and Abby Murphy.

We especially acknowledge the assistance of UKScrappers and ForKeepsakes Magazine. For more information, go to www.ukscrappers.co.uk and www.forkeepsakesmagazine.com

A special thank you to my mother, Joanna the First, who took over carpool duty and freed up hours and hours of my time. And, last but not least, thank you to David Slan, peacemaker, financier, business coach, friend, and dear husband.

ISBN 0-9762784-0-5

Published by:
Spot On Publishing
7 Ailanthus Court
Chesterfield MO 63005
USA
(636) 519-1612

Visit our website: www.britishscrapbooking.com

thank you
MARY ANNE WALTERS

cardstock
font (Bodo Black Squares)
ink: ColorBox